THE ART OF PALESTINIAN EMBROIDERY

Leila El Khalidi

THE ART OF
PALESTINIAN EMBROIDERY

Saqi Books

British Library Cataloguing-in-Publication Data
A catalogue record for this book is available from the
British Library

ISBN 0 86356 038 5 (pbk)

© Leila El Khalidi, 1999
This edition first published 1999

Saqi Books
26 Westbourne Grove
London W2 5RH

To my parents,
who loved beautiful handwork.

To my children,
who accepted and encouraged my belated steps in embroidery.

To pet cats and arthritis
and being awake
at the oddest of hours.

I made my song a coat
Covered with embroideries
Out of old mythologies
From heel to throat . . .

(*from* W. B. Yeats, *A Coat*)

Contents

List of Illustrations	8
Acknowledgements	9
Preface	13
Introduction	15

Part I. Prototypes of Palestinian Embroidery

1. Cross-cultural Factors: Chronology with an Emphasis on the Use of Silk Thread in Palestinian Cross-stitch Embroidery	19
2. Migration of Symbols	31
3. Geographical Divisions in Pre-1948 Palestine	35

Part II. Traditional Costume up to 1948

4. Pageantry in Costume	39
5. Embroidery as a Folk Art	47
6. Developments in Embroidery Skills	57

Part III. Motifs in Cross-stitch Work up to 1948

7. The Origins of Cross-stitch Motifs	65
8. Motif Selection	71
9. Folk Appellation – A Charted Language	77

Conclusion	83
Appendix I. An Assessment of Palestinian Sample Fieldwork	85
Appendix II. A Note on Terminology and Translation	89
Appendix III. Folk Appellations, 1948: An Alphabetical Listing	91
Notes	143
Bibliography	147
Index	169

Illustrations

Between pages 32 and 33
- Map of Palestine, showing costumes from the major areas
- Lamia Abu Saoud Khalidi in traditional Ramallah costume
- Afaf Khalidi Husseini in traditional Bethlehem costume
- Najla Raad Krikorian in traditional bedouin costume
- Aida Krikorian Qawar in traditional Bethlehem costume
- Marie Adamidi and Najla Raad in traditional Bethlehem and bedouin costume
- Iskouhir Krikorian in traditional Ramallah costume
- Bahia Mardini Khalifeh in traditional Ramallah costume

Between pages 64 and 65
- Gate entrance to old Jerusalem house built in 1790
- Inside hall of the Palestine Arab Folklore Centre Museum, 1980
- Jerusalem bridal city costume (Turkish style), 1890s
- Bedouin bridal costume from Khan Yunis
- Bahia Mardini Khalifeh in traditional city cape/coat
- Amira Hamed in contemporary costume
- Amira Hamed and others in contemporary costumes
- Itidal Mahmud in contemporary Ramallah costume

Page 81
Women's Handicraft Society shop, Amman, 1955

Page 82
Inside the Women's Handicraft Society shop, Amman, 1955

Acknowledgements

The present material is derived from archives incorporating a variety of sources in different locations: from visits to museums or private collections, or through acquisition of their printed catalogues; from Palestinian public libraries; from permanent or travelling exhibitions; from workshops arranged by such bodies as SAMED (see below) or by charitable organizations; from Palestinian homes; from detailed descriptions provided in Palestinian books, magazines and newspapers; from audiovisual material; and from existing official archives. Moreover, the investigation was not restricted to Palestine alone, but extended to other parts of the Arab world where concentrations of Palestinians were to be found, notably in the numerous refugee camps. The search never ended.

There was little choice as to the places visited during my work, and there was still less choice as to where I lived. For long periods I lived with my family in Palestine, Lebanon, California, Jordan, Egypt, Lebanon again and Greece, and I toured parts of the US, the UK, France, Italy, Switzerland, Syria, Saudi Arabia and the United Arab Emirates, where I contrived to visit the available libraries and museums, before finally settling once more in Jordan in the hope that, some time and somewhere, I should be able to return to my

Palestinian roots. It will be appreciated that raising four children, who in turn presented me with nine beautiful grandchildren, imposed certain limitations!

On the more personal level, I should like to express my heartfelt thanks to numerous people who, over a period of almost thirty years, have encouraged and supported me in the efforts leading to the present work: to my library studies professor, Isabel V. Hathorn, who, back in 1967, first initiated me into the organization of material and classification of knowledge; to Fawz Touqan al-Azm for providing me with my first motifs and awakening my interest in the field; to Hilda Phar'oan, who gave me enduring support through the exchange of ideas and culture and other shared interests; to Jumana al-Husseini, who allowed me to copy her small authentic collection; to Samia Taqtaq Zaru for constant encouragement in the process of documentation; to my assistant Nermin Jubran Musa, who provided her grandmother's costumes with their folk appellations for documentation; to my daughter Fatima al-Husseini, who translated parts of my original manuscript for publication in the Amman periodical *Samed al-Iqtisadi*; to Leila Touqan Abul-Huda and Mawya Abu Ghanimeh al-Bakri for their constructive appraisal of the initial ideas for my work; to Hadla al-Ayyoubi for suggestions on my original draft; to Najwa al-Husseini Nusseibeh for the checking and authentication of chronologies; to Khawla al-Husseini, together with her sister Nuzha and daughter Rana, for their enthusiasm in copying authentic samples, which they then displayed in their homes; to my daughter-in-law Mary Harriman Husseini, who, in the midst of raising four children, found time to read, revise and type my bibliography; to my friend and classmate in early university years, Salma Khadra Jayyusi, for her valuable help in expediting the final publishing arrangements; to Christopher Tingley for his scrutiny in the editing of the final manuscript; and, most especially, to my granddaughter Sara Husseini, who was able, even at eleven years old, to make her personal contribution to the final form of the bibliography.

I also wish to thank my son Nafez Husseini for his computer and software technology expertise and Dana Sa'ad of Athens for her patience in executing the computer icon designs, and Karam Annab and Nisrene Milkawi of Info-Graphics, Amman, for the costume location map shown between pages 32 and 33.

I should further like to thank the following: Samiyyeh Salem (Um

Mustafa) of Amman, for her extensive embroideries and wide vocabulary of motifs; Siham and Nellie, who enriched my archives in Beirut; Kirya Dhina, who reconstructed my embroidery files in Athens; Amira Hamed for the rechecking and relabelling of motifs and for unearthing further contemporary motifs for my ever-growing files; and, finally, to the countless costume-clad women – their patterns preserved after names and faces were forgotten – who supplied me with appellations as a result of casual inquiries.

Finally, I cherish the memories of my hugely worthwhile work with SAMED, the Palestine Martyrs' Works Society, and should like to pay special tribute to Ahmad Qurei' (who, since the SAMED days, has been Palestinian chief negotiator and is now an elected deputy, having been elected head of the first Palestinian Legislative Council in March 1996) for providing all possible work and funding facilities, along with ever-open doors, throughout the period we worked together, including the contribution towards publishing this book.

Preface

My life in Lebanon, between 1972 and 1983 (the period in which much of this work was undertaken), was hardly a tranquil one. Movements even within city limits, let alone outside them, were restricted for a variety of reasons, and, with working hours being intermittent, it became essential to find other functional interests. It was in this way that I first turned to the study of handwork and, in particular, of embroidery.

My first task was to seek out suitable tools to develop my own adult canvas work: specifically, silk thread, canvas, needles and published sketches. The Middle East region, once a distribution centre for trade along the Silk Route (first–eighth centuries AD) and possessor of its own silk trade in the sixth century AD, was of course ideally suited for this. During duty-travel visits to Damascus I found a small shop in the souq in the Old City, brimming with tinted silk skeins that were unlabelled either for quality or quantity – lacking, in other words, the information normally required when buying materials for sewing or knitting. I came out carrying several kilos of silks and made further trips to the shop thereafter.

I began my own embroidery work in 1975. Death or personal injury was commonplace in Lebanon at that time, and I was well aware

it could touch me too – indeed I had already suffered some injury. My interest in embroidery was unaffected, however, and I made sure my chief embroidery manuals and some books on cross-stitch work, together with my own rough sketches, pieces of canvas and most of my silk thread, always travelled with me in my overnight case.

That was the start of an absorbing study. As time went on, I began to seek out new ideas on thread and canvas, along with further bibliographical material on stitchery, embroidery and cross-stitch work. The present work offers some of the fruits of this research.

Amman, May 1998

Introduction

Folklore, whether in its general or its specific aspects, is a subject of interest to sociologists, social psychologists, ethnologists, archaeologists, museum curators and national librarians; while to interested observers of culture and collectors of folk material, too, displays of folk art and craft provide both enlightenment and enjoyment. The collection and preservation of folk material have attracted interest in many countries of the world, and there are numerous national institutions providing displays and exhibitions of traditional culture in their museums and galleries.

However, Palestinian folklore material has become dispersed, with samples and published material mostly only available in museums, major libraries and small private collections. Some early collectors of costumes were noteworthy for their interest in the identification, authentication and preservation of traditional Palestinian costumes, and provided invaluable displays and publications, but full details of these are at present unavailable.

In fact, significant sources of information on Palestinian embroidered arts can, to date, be numbered in the tens, as opposed to the hundreds and thousands of such sources available for many other cultures. Where found at all, the relevant material is generally

embodied in a chapter, or even a paragraph, within an overall work, or else in the form of illustrations with little documenting text. Sketches or photographs have, it is true, been widely disseminated by Palestinian information services, or used for tourist advertisements, but these tend to be only sparsely documented.

PART I

PROTOTYPES OF PALESTINIAN EMBROIDERY

CHAPTER 1

Cross-cultural Factors: Chronology with an Emphasis on the Use of Silk Thread in Palestinian Cross-stitch Embroidery

It is obviously beyond the scope of the present work to provide a detailed history of embroidery. Yet the material treated in this book cannot be fully appreciated without some understanding of a historical background that stretches, ultimately, into the distant past and involves cross-cultural influence and fertilization on an international scale. The aim of the following chronology is strictly pragmatic: to give the reader, through an accumulation of varied detail, an impression of the complex world factors underlying modern Palestinian embroidery.

Circa **5000 BC**
The Chinese begin to cultivate the mulberry silkworm, learning how to unwind the cocoon spun each spring and make gossamer thread.[1] Dyed and woven into fabric, silk becomes the mainstay of the Chinese economy, being used as a currency and hoarded along with precious stones and gold.

5000–4000 BC
Linen cloth found in Egypt apparently dates back to this period, having perhaps originated in the Near East or in various parts of Asia, Europe and Africa.[2]

3500 BC
The Arabian peninsula becomes a crossroads of early migrating populations, with waves of migrants passing through. The first of these waves splits into two groups, one moving on to Egypt and the Nile Valley, the other discovering the Fertile Crescent and settling along the River Jordan in the area eventually known as Palestine. A further wave settles in Mesopotamia along the Tigris and Euphrates rivers.

3200 BC
Egyptian art begins to develop, passing, eventually, through pre-historic, Graeco-Roman, Byzantine and Coptic phases, over a period of thirty-one dynasties to AD 640.[3]

Circa **2700 BC**
Asians cross the Bering Strait into Alaska and move southwards, settling in the Valley of Mexico. Descendants of these nomadic hunters cultivate maize and settle in villages.

2500 BC
A further wave from the Arabian peninsula – a Semitic group known as Canaanites and possessing a dominant culture – settles in the lowlands of a region corresponding to later Palestine.

2200 BC
This date marks the approximate beginning of historical Chinese art.[4] The Xia dynasty (*c.* 2200–1766 BC) is stated by Chinese historians to have produced silk.

Circa **2000 BC**
Craftsmen using abstract forms employ, among other decorative motifs, geometric bird's-eye-weave prototypes of the Holy Chequer ornament later found in early Christian weaves.[5]

2000–1100 BC
In the Middle East, the Canaanites are followed by the Amorites, who, after settling in Syria and Lebanon and the lower Tigris and Euphrates and intermingling with Mesopotamians, come to be known as the Babylonians and Assyrians. There are five groups in all, Semitic in

culture, custom and tradition, and using various languages.

By this time, the region has become a world centre of agricultural production and industrial and mercantile activity. Peasant tillers supply the manufacturing and trading cities with food, while skilled craftsmen make products for the markets. Cities like Memphis, Haran, Nineveh, Babylon and Ur flourish.

The wealth of the Fertile Crescent proves a temptation to the Indo-European civilization to the north, and to the Persian and Mongol civilizations to the east. The Egyptians develop a national state, the Sumerians a group of city states. All strive for domination of the Fertile Crescent.

1650 BC

The Phoenicians bring the arts and crafts of Babylon and Assyria to mainland Europe and England in exchange for tin. In Tyre they trade in purple derived from the Mediterranean murex shellfish.

1500–1400 BC

In a third wave from Arabia, Phoenicians migrate to Lebanon and Aramaeans to Syria and northern Jordan, while the Hebrews establish a foothold in Canaan. Amenhotep II of Egypt marches as far as the Sea of Galilee, returning with 3,600 *Apiru* prisoners of war.

In the wake of hard times in Canaan, the Jews and other peoples migrate to Egypt, communities surviving there until after the times of Ramses II. The *Apiru* or *Habiru* (Hebrews) are regarded as enemies by the Pharaoh.

Circa 1400 BC

Mosaic law forbids the use of figurative art with regard to embroidered objects at religious sites. Idols are replaced by the use of abstract design.

1300 BC

The Jewish exodus takes place following harsh treatment by the Pharaoh Ramses II.

1200 BC

Ramses II's successor Mernaptah wipes out his enemies. Subsequently Ramses III vies with the Hittites for control over Palestine. Inspired by

textiles and dyes, the Egyptians begin imitating embroidery in paintings and they work in enamel, metals and glass.[6]

Chaldean art begins to give way to Assyrian art, both having sprung from Egyptian prototypes.[7]

Tenth century BC
The Hebrews establish themselves in central Canaan, surrounded by Canaanites, Phoenicians, Hittites, Aramaeans, Ammonites, Moabites and Edomites. The monotheistic Hebrews subsequently become known as Jews, charting their social and political history in what is now known as the Old Testament.

The Chinese of the Zhou dynasty begin writing with a brush on wood and silk.

900 BC
The Mayas begin to settle in villages in Central America.

Seventh century BC
Foreign invasions of Egypt begin.

Sixth century BC
The Persians become established in Asia, their art developing with the incorporation of Assyrian, Greek and Egyptian elements.[8]

Examples of the vertical loom appear on Ancient Greek vase paintings. As far as the arts of embroidery are concerned, the idea, according to the *Atlas of the Greek World,* is to 'decorate and divide up a surface with infinite variations of texture at the same time, to represent, to impress'.[9]

International trade now begins to flourish.[10]

Fifth century BC
The term *aribi* has now come to be used in inscriptions and writings, with reference to desert people in general and specific nomadic individuals in particular (the word *arabaya*, later 'Arabia', is first found in Greek writings and designates all the desert areas of the Middle East inhabited by peoples speaking a Semitic language). However, the Egyptians, Canaanites, Hebrews, Phoenicians, Assyrians and Babylonians all retain a specific cultural identity. The Palmyrans and Nabateans migrate from Arabia.

Examples of the earliest oriental sewing, discovered in frozen burial sites in Russia, date back to this period.[11] South American Indian embroideries, surviving in funerary bundles, are also said to date from this time. A fragment of Greek embroidery belongs to this period.

Fourth century BC
The Teotihuacanos rise in Central America, village life flourishing there up to AD 100. The Pyramid of the Sun is built and trade routes are opened.

The city of Alexandria is founded (331 BC), following Alexander the Great's conquest of Egypt, and subsequently becomes – under Ptolemy I and Ptolemy II – the architectural and cultural centre of the Mediterranean world.

Second century BC
The world map of Ptolemy, showing East Africa, India, Ceylon and Malaya, reflects growing world communications.[12]

True world trade begins in China, under the Earlier Han dynasty. The Chinese export silk fabric to Asia and Europe by camel caravan and yak. Cargoes are also shipped westwards, goods finding their way as far as Rome.[13]

A quantity of silks, including embroidery thread in twenty colours, is buried with the body of a noble Chinese lady (*c.* 160–150 BC) in a family tomb at Mawangdui, near Changsha (also Tanzhou) in Hunan. Excavations at the site have revealed a variety of silks, ranging from gauze and damask to brocade, with geometric and 'cloud' patterns printed, painted or embroidered on them, and a large number of books written in ink on silk.[14]

First century BC
The Romans, the Egyptian Ptolemaic dynasty, the Seleucids of Asia Minor and the Macedonians in southern Europe all become rivals for possessions in the Middle East. New states emerge and, while languages remain fairly constant, cultural variety becomes widespread. By the mid-first century BC the Romans have a firm hold in the Middle East, while separate Semitic cultures integrate and assimilate, becoming exposed to Persian, Greek, Roman and other genetic infusion, with a resultant transfer of religious and political ideas,

customs, traditions and ethnological aspirations, though Semitic language and lore survive.

First century AD
Christianity emerges in the Middle East. Tent-makers in the Far East begin to use Kelim abstract design in their weaving.

The British queen Boudicca (Boadicea) (d. 62 BC), captured by the Romans following her major revolt against them, is described as wearing a fur-lined mantle of embroidered skins, similar in principle to those still made by the Inuit and by North American Indians.

Second century AD
Techniques of Chinese embroidery, a source of fascination to travellers, begin to be reflected in European needlework.[15] The Silk Route reaches its zenith in the Later Han dynasty, trade in silk handicraft remaining for the moment a Chinese monopoly.[16]

Third century AD
With silk now almost worth its weight in gold, the Chinese seek to retain their monopoly by forbidding the export of silkworm eggs on pain of death, but the Japanese apparently obtain worms illegally around this time.

Fifth century AD
A Chinese bride reportedly smuggles silkworms to Central Asia in her bridal trunks.

Sixth century AD
According to legend, the Emperor Justinian sends two monks to China (AD 550) to secure a supply of silkworms and so break the Chinese monopoly. Worms are smuggled to the Byzantine court at Constantinople in a hollowed cane and a native silk industry is founded. Though wealthy Byzantine connoisseurs prefer the superior Chinese silks, the Byzantine industry quickly becomes important and lucrative.

Wars in Persia disrupt the Chinese silk trade, leading to negotiations with Ethiopia to establish an alternative route (AD 532).[17]

Seventh century AD
Islam and Islamic rule spread from Arabia, leading to a deep implantation of Arab culture over a wide empire.

Eighth century AD
As the silk looms of Constantinople go into decline, those in Thebes and other Greek and Syrian cities increase production and improve methods of manufacture. The Silk Route is effectively closed following the Muslim conquest of Persia.

Charlemagne decrees the production of woad, cochineal and madder as dyes.

Ninth century AD
The earliest surviving piece of West European needlework, a remnant of an English-made chasuble found at Maeseyck in Belgium, dates to this period. It is worked in coloured silks, gilt thread and seed pearls and depicts birds, animals and monograms in interlacing roundels.[18]

Tenth century AD
The Magyars introduce Asian-Chinese folk embroidery to the Balkans following their invasion of Hungary.

Eleventh century AD
The Bayeux Tapestry (probably commissioned by William the Conqueror's half-brother Odo, bishop of Bayeux) is woven to depict and commemorate the victory of the Normans at the battle of Hastings (1066). The tapestry, 70 metres long by 50 centimetres high, represents a long narrative produced on separate, jointed parts by professional teams. The material is simple, with the use of coloured silks but no gold. The workmanship is English in design, the needlework showing some 600 figures, together with animals, birds and fish.[19]

Twelfth century AD
The Norman ruler of Sicily, Roger II, invades Greece (1147), takes a number of silk weavers captive and establishes them in Palermo and Calabria to teach Greek methods of silk culture.[20]

Thirteenth century AD

The silk industry is promoted in North Africa, Spain, Portugal and Sicily in the wake of the Arab conquests. Spanish and Sicilian production becomes substantial.

St Francis, having tended Christian and Muslim soldiers in the Holy Land, returns to Assisi with examples of religious embroidery and so initiates what is known as Assisi counterchange cross-stitch work. The motifs are stylized birds, animals and geometric shapes, and the style reflects the influence of Arab and oriental design. It is characterized by a black border, worked with silk thread on white linen in red, blue, brown, yellow and green pastels. The work is subsequently carried on by Franciscan White Friars and White Nuns.

Frederick II of Sicily brings Jewish, Christian and Muslim craftsmen to Palermo to weave designs in silk.

The Knights Templar take religious Venetian textile designs to the Transylvanian Saxons, these supplying the prototype for later Transylvanian cross-stitch.

Fourteenth century AD

Abu Said II Khan is recorded (1323) as presenting the Mamluk sultan al-Nasir al-Din Muhammad ibn Qalawun with a gift of 700 silks (probably made in Persia, where painters and weavers were profoundly influenced by previously unfamiliar Chinese drawings and textiles), with the name of the sultan woven into them.

Two surviving silk patterns in Regensburg and Danzig show cursive Arabic writing and panels with Chinese animals, lotus palmettes, crescents, diaper or trellis patterns.

Turkish designs now incorporate Crusader, Pharaonic-Coptic, Persian, Chinese-Mongol and other elements, interwoven with Semitic-Arab motifs. They continue to be ornamented and overworked by the use of gold and silver threads. These designs subsequently spread over the Fertile Crescent region with the growing power of the Ottoman empire.

Fifteenth century AD

European painters (including Botticelli and Dürer) produce designs for embroideries,[21] while in France, under Louis XI, silk is manufactured in Tours, with later manufacture at Lyons, Montpellier and Paris.

In China and Japan exquisite garments are worked in gold thread and pure silk on satin. In South America mythological creatures are woven and embroidered in handspun llama and vicuna hair.[22]

Sixteenth century AD

Cocoons are successfully raised in France during the reign of Francis I (1515–47). Frederick di Vinciolo, attendant designer to Catherine de Medici, produces a pattern book (1587) entitled *Les Singuliers et Nouveaux Portraits et Ouvrages de Lingerie*. Woodcuts appear, as modebooks of counted patterns, in Zwickau, Saxony, Cologne, Venice, Lyon, Nuremberg and Paris.

In China embroidery is introduced under the Ch'ing dynasty, replacing earlier painting techniques. Textiles are characteristically ornamented with pearls and coloured beads, gold and silver thread, dragons and red flames of wisdom on a yellow silk background.

Seventeenth century AD

In Britain haberdashers, weavers and dyers become wealthy merchants. The London Broders' Company, incorporating all the important suppliers, becomes a powerful organization.[23] Huguenots settling in Britain attempt to manufacture silk, but with little success.

The Jesuits settle in China under imperial patronage.

Eighteenth century AD

A new method of 'throwing' is developed, and British silk replaces French silk in European markets, though a French revival in the Napoleonic and subsequent period almost ruins the British industry in its turn. British crewel work characteristically features unreal flowers, exotic foliage and oriental blooms. Floral needlework in tent- and cross-stitch depicts natural garden blooms in controlled groupings, suitable for carpets, chair seats and other furniture. Work in silk, more precise and naturalistic now, becomes a sophisticated pastime. Eventually the industrial revolution leads to the invention of mechanical weaving devices, with subsequent drastic unemployment for British handloom weavers.

In France Madame de Maintenon, mistress of Louis XIV, founds an embroidery school at the Convent of St Cyr, where daughters of the aristocracy learn needlework, especially canvas embroidery.

In the Austria of Maria Theresa, many reformed Lutherans move

to Transylvania, so beginning the flowery style of folk cross-stitch.

In North America the native Indians use wool, cotton, beads, porcupine quills and moose hair to portray stylized lightning, buffalo and wild flowers, while early European settlers make cotton patchwork quilts depicting flowers and animals among their motifs.[24]

In China an imperial proclamation (AD 1759) initiates the Twelve Symbol robe, containing twelve ancient symbolic motifs representing the virtues of a good and all-wise king, along with other Manchu Chi'ing robes. Chinese symbols of the period depict the natural world and the entire universe under the dominion of the Emperor Dragon, the symbolism being completed by human figures representing the spiritual dimension. There continue to be additions to and variations on the original twelve symbols (which comprised a five-clawed dragon, sun, moon, stars, mountains, birds, grains, grasses, the chou circle signifying longevity, animals, and astrological and calligraphic motifs).

Nineteenth century AD

Berlin work, a form of grossly stitched needle-painting featuring garish, blowsy blooms, is established in Germany and subsequently (c. 1820) brought to Britain. Printed and coloured patterns are produced on squared paper for canvas embroidery. The wools used are brightly coloured, but originality and artistry are both limited.[25] In 1851 the Great Exhibition in London's Hyde Park includes specimens of embroidery.

Silk manufacture flourishes in Switzerland and Germany, while the first American silk mill (established in 1810 in Connecticut) prospers in the second half of the century following the setting up of protective tariffs. Similar tariffs in Russia benefit the silk industry there.

Late in the century (and into the early part of the next), the ailing Ottoman empire promotes embroidery through mission schools and philanthropic welfare projects. Embroidery outlets, generally under the supervision of nuns around the Fertile Crescent region, use local women to produce work which is then sold privately on commission or at the outlets themselves.

China, Japan and India all export raw silk, China exporting large quantities from Shanghai and Canton.

Twentieth century AD

At the turn of the century 'birds, hares, horses, wild and mythological animals with borders and geometrical shapes containing foliage of all kinds' become the main inspiration for motifs in embroidery.[26]

In non-Western countries local crafts suffer from competition with mass-produced goods. Handloom weaving suffers drastically in places where it once flourished, though local craftsmen continue to produce traditional cloth goods for tourists and collectors.[27]

Japan, China, the USSR, India and South Korea become the principal producers of silk, Japan the principal consumer.

In the Balkan peninsula embroidered cross-stitch work becomes integrated with Magyar-Hungarian work, with a resultant intermingling of Slavic motifs and those demonstrating Chinese origins.

A stall run by the Royal School of Needlework at an art fair in London (Olympia/Kensington, February 1996) shows a new three-dimensional approach to embroidery and features some exquisitely executed hangings with motifs based on students' sketches of notable architecture in city and country (in addition to more conventional natural motifs).

CHAPTER 2

Migration of Symbols

National museums and their publications (from the late nineteenth century to the early twentieth), art nouveau sketches, watercolours, other paintings and photographs offer a wide variety of sources. All over the world, permanent collections and temporary exhibitions, notably those concerned with ethnic collation, are available either for direct viewing or through brochures, slides and other audiovisual means, while the necessary publicity is provided by art critics in regular international newspapers both before and after particular collections are displayed.

Pre-1948 Palestinian costumes, and Palestinian artworks in general, are well displayed by, among other places, the Rockefeller Museum in Jerusalem, the British Museum and the Museum of Mankind in London, and the Pergamon in Berlin, while one source notes the Dar Batha Museum in Fez (Morocco) as having a collection portraying the migration of Islamic cross-stitch design and indicating its causes.

Although symbols date back, ultimately, to Chinese symbols found around 5000 BC, current research suggests that the earliest forms of Holy Land embroidered cross-stitch can be dated to around the eleventh century AD. Very early symbols brought to Europe by

pilgrims show an interplay of Holy Land abstract geometric styles with naturalistic Eastern forms, with each geographical region evidently imbuing patterns with its own distinctive spirit. Sources further indicate a treasure house of ancient religious symbols for lovers of religious embroidery. Counterchange fantasies of Syrian-Phoenician origin are said to have been brought to Assisi by St Francis, who tended wounded Christian and Muslim soldiers in the Holy Land. The resulting Assisi embroidery, described as displaying a strange interplay of foil and form, developed its own religious significance.

This Assisi work – a counted thread embroidery with stylized outline representing birds, animals and geometric shapes – dates from the thirteenth and fourteenth centuries and was worked by nuns to provide altar cloths. Examples are preserved in various museums and churches in Italy. Motifs reveal the influence of Arab and oriental design, with further artistic improvisations and touches added through counterchange.

Sources also indicate such traditional appellations as: 'Holy Candelabrum' (the Persian Muslim version); 'Holy Star of Bethlehem' (Moorish interlace); 'Holy Keys of Jerusalem'; 'Guardian Angels' transformed into birds (known as 'Skalli', this being the Arabic term for 'Sicilian' Norman-Arab twelfth-century designs); 'Gates of Heaven' (gates and crosses); 'Tree of Life'; 'Greek Cross'; 'Holy "S"' (serpent); 'Trefoil'; and the 'Syrian Inhabited Scroll' (describing Hellenistic ornament from the beginning of our era). Other appellations, implying a debt to other cultures, might also be cited.

The period from the fifteenth to the seventeenth century saw the working in counterchange of elaborate biblical scenes, animals, plants and mythological motifs. Old Testament scenes were derived from woodcuts, later supplemented by medieval church sculpture. Embroidery was considered a church art by the Italian Renaissance, such work combining a free-surface stitchery outline.

Assisi counterchange work used unfilled, defined, stylized motifs; the background was embroidered in one pastel colour, generally on white, using cross-stitch, such as Italian cross, long-armed stitch, four-sided stitch or Holbein. The outline was generally in black. Counterchange, however, lost its popularity in the eighteenth and nineteenth centuries before being eventually revived in the twentieth. The function now is secular rather than ecclesiastical, using Holbein and cross-stitch but no drawn thread technique, and the designs,

Map of Palestine, showing costumes from the major areas (design: Karam Annab and Nisrene Milkawi).

Lamia Abu Saoud Khalidi in traditional Ramallah costume, Jerusalem, 1935 (?) (photograph: John Krikorian).

Afaf Khalidi Husseini, aged six, in traditional Bethlehem costume, Jerusalem, 1937 (?) (photograph: John Krikorian).

Najla Raad Krikorian in traditional bedouin costume, Jerusalem, mid- to late 1920s (photograph: John Krikorian).

Aida Krikorian Qawar, aged around seven, in traditional Bethlehem costume, Jerusalem, 1935 (?) (photograph: John Krikorian).

Marie Adamidi and Najla Raad in traditional Bethlehem and bedouin costume, Jerusalem, 1920 (photograph: Raad).

Iskouhir Krikorian in traditional Ramallah costume, Jerusalem, 1920 (photograph: Raad).

Bahia Mardini Khalifeh in traditional Ramallah costume, Jerusalem, 1930 (?) (photograph: John Krikorian).

whether representational or abstract, have become simply utilitarian and decorative.

A comparison of uncharted motifs of Palestinian embroidered costumes with other charted motifs, as derived from bibliographical sources, leads us through a range of world cultures, with cultural and religious influences clear though sometimes distinctly overlapping. Examples of such cultural interchange may be seen, for instance, in the following:

1. Chinese-Mongol (modern Chinese artworks).
2. Hellenic (from Byzantine to modern Greek).
3. Roman (Middle Ages and Renaissance, from Assisi, through Venetian, to modern Italian).
4. Mid-European German, trans-Danubian, Transylvanian, Slovenian, Slavic to modern Yugoslav, Romanian and Russian.
5. Scandinavian (modern Norwegian, Swedish, Finnish, Danish).
6. Persian/Farsi designs (Kelim to modern Iranian).
7. Syrian-Phoenician; Ottoman Turkish; Macedonian[1] to modern Turkish.
8. Magyar (from Mongol Chinese to modern Hungarian).
9. Neo-Gothic; West European, modern British Isles.
10. Arabesque Muslim (from Umayyad, through Abbasid to modern Arab Middle Eastern).
11. Coptic Christian/Muslim Egyptian (North African to modern Maghrebi).
12. Assisi (modern French, Italian, Spanish and other Latin countries).

It might also be maintained, in this context, that Chinese embroidered arts and symbols, as portrayed in the Twelve Symbol robe (see the Chronology under 'eighteenth century AD'), made their way via the Pacific Ocean to the West Coast of the United States, whereas European embroidered arts made theirs through the East Coast. Whatever the case, samples of American cross-stitch art available to us reflect both early Chinese and later European origins. Symbols in Native American Indian and contemporary Inca pan-American cross-stitch work show these multi-cultures existing in, or migrating to, the

North, South and Central regions of the Americas. As for present-day African cross-stitch work, this probably reflects the influence of Christian missions.

One might surmise from all this that the cross-stitch motifs used in pre-1948 Palestinian embroidery were ripe for exchange. Symbols previously cited as having originated in the Far East took form, style and significance in the Holy Land, whence they moved north with Christian saints, holy men, pilgrims and travellers: through Muslim Turkey to the Balkans,[2] trans-Danubian regions and further north to Slavic areas; with Islamic expeditions to North Africa and Spain in the west; to Persia in the east; and through Phoenicia/Syria/Mesopotamia. There was also an integration of distinctive Chinese-Mongol designs with Persian and Magyar symbols by a separate route not involving the Holy Land (see references to the Silk Route in the Chronology). Blending into designs evidently imbued with their own particular spirit, Slavic, Scandinavian and other cross-stitch styles took on the themes, developed them and varied the stitches accordingly.

Those interested in further study on the migration of symbols are referred to the references in the bibliography below; these nevertheless represent only a small selection of the material available for dipping into such a vast 'pool of knowledge'. Indeed, the sources published or in press are almost endless. The ideal approach, originally envisaged for this study, would be a cumulative one, making use of modern technological library techniques.

This present work, however, must restrict itself to an illustrative exploration into authentication, documentation and folk appellation, with specific reference to Palestinian motifs; and even these, with their numerous variations and contemporary improvisations, are too numerous to be included within a single treatment. A division, in the context of historical migration, between pre-1948 and post-1948 history is already a sufficient task.

CHAPTER 3

Geographical Divisions in Pre-1948 Palestine

Palestinian embroidery designs were descriptive of regional location. These locations were not, however, distinct in the sense of being based on formal administrative divisions or boundaries within Palestine, whether established by the Crusades, the Ottoman empire, the British mandate or the modern Israeli occupation. As with costume in other countries, the assimilation and adoption of symbols was rather influenced by neighbouring communities and by other peoples residing in the area or passing through it. The final styling of costume shows, in fact, similarities with that of neighbouring Arab peoples. Region, in this context, involves rough divisions based on north, south, east, west or central, then north-east, north-west, etc, usually by initial reference to the Holy City of Jerusalem and other sacred places. In form, style and appellation, motifs were linked to everyday village and farm life, familiar rural scenes and objects within the general environment.

Although, as mentioned above, regional distinctions were never precise, geographical foci (using present-day place names) were principally the larger towns and cities, as follows:

1. Jerusalem, including Jericho and Lower Ghor ('Ghor' referring to the Jordan river basin).
2. Bethlehem/Beit Jala.
3. Ramallah/al-Bireh.
4. Northern Palestine and Galilee, including Akka (Acre), Nazareth and Upper Ghor.
5. The Nablus district and Middle Ghor.
6. The Jaffa/Beit Dajan district, including Lydda, Ramleh, Asdud, etc.
7. The Hebron district.
8. Gaza and the Gaza Strip, including the Negev desert.

Costumes pertaining to these areas might be descriptive, distinctive or distinguishable; they might also, in sophisticated terminology, be called *distingué*. Geographical location, local culture and outside influences all combined to localize garments, to integrate them with customs, traditions and the way of life generally, while the greater or lesser assimilation of these influences reflected the ability of particular individuals or local family communities to adopt and adapt. A comparison of Palestinian costume with that of neighbouring Arab countries and peoples reveals both differences and similarities, the overlap showing, once again, how vague the formal regional boundaries inevitably were in practice.

PART II

TRADITIONAL COSTUME UP TO 1948

CHAPTER 4

Pageantry in Costume

The reconstruction of traditional Palestinian costume is not a particularly difficult task, for vivid examples proliferate, mainly in museums, whose collections contain prototypes or archetypes going back to around the eleventh century, but also in private collections to be found in Palestinian homes. There are also some fine examples in the homes of collectors who spent part of their lives in the Middle East, and particularly in the Palestine of the mandate. The problem is finding all of these in one place.

Some early sketches date back to around the sixteenth century: many of these, showing figures clad in costume, were reprinted in travel books of the eighteenth and nineteenth centuries. Palestinian costumes are still worn to this day around the West Bank and Gaza Strip, and also, commonly, in refugee camps in Jordan and Syria. Watercolours, drawings, etc from the late nineteenth century to the present day give an idea of the colours used; and, with descriptive sketches of these traditional costumes so easily provided, a detailed written text would be redundant. Sketches of the Holy Land by David Roberts and other artists have left a legacy of artistic landscapes, while Susan Sotheby's costume sketches were once very popular and sold in collections for framing.

Traditional Costume up to 1948

Palestinian costume included an outer garment covered with nbroidery, and there was an accompanying headdress. Undergarments, such as long cotton kaftan-like dresses, printed or striped, also varied, while shorter dresses, with long baggy trousers matching the material of the dress or outer garment, sometimes carried further embroidered work. In the northern regions of Palestine (see map between pages 32 and 33) there was an evident variation in costume style: overcoats and long blouse-like dresses, with trousers underneath, were common. On the other hand, some areas in the central hills did not use embroidery at all, striped material such as Syrian *saya* being used instead. Differences in costumes for the Jerusalem, Bethlehem and Ramallah districts were also in evidence, while those in the Jaffa–Beit Dajan district similarly varied from those around Hebron, Gaza and the Gaza Strip. There were, furthermore, two similar but distinctive styles of bedouin costume that marked the wearers out as belonging: either to the Lower to Middle Ghor region (Jericho or Beisan, for example); or to the south, in and around the Negev area and further into the Sinai desert. On the other hand, the northern bedouin, who may have crossed the Jordan from Upper Galilee or into Syria and Lebanon, wore nothing descriptive and left no mark on Palestinian embroidery.

Costumes had their various accessories. Headdresses, which varied from one area to another, included embroidery around the visage line; this acted as a padding, allowing silver and gold coins to be sewn on as ornament. Embroidered or plain over-jackets in sleeveless bolero styles were worn either as protection against the weather or on festive occasions. These varied from plain braided to highly ornamented gilded types, and were extremely decorative.

An oblong piece of gauze material, plain or coloured and with needlework edging, served as a stole-type scarf worn as a cover to the headdress. Later, square shawls, with long fringes and embroidered with flowered silks, appeared as an alternative, these reflecting Chinese or Mexican influence. Common in the Ramallah–al-Bireh region, they were probably introduced by émigrés from North and Central America.

Village and bedouin women were not required by their menfolk to cover their faces in mixed company. Veiling was, however, practised in cities, as a result of Ottoman-Turkish influence. The custom has been retained in very traditional or strongly religious societies and can

still sometimes be seen, in cities and towns, in the old quarters and souqs.

Footwear, varying from slippers to low boots, was purely protective in nature. Belts, regarded as back supports, were made from squares of striped material. There were also bands of thickly twisted cotton rolled into a cylindrical form, placed on the head as a work aid when carrying water. Silver or gold jewellery reflected the wearer's socio-economic status.

Village dress differed from city wear, which was styled along Western lines. In the city, the choice of outer garments was made by the individual family and could vary from short-sleeved, bare-legged sandalwear to heavy, austerely styled over-garments, with headscarves as seasonal wear. Traditional societies and quarters, however, sometimes insisted on head-to-foot covering, normally black throughout, though sometimes white, and totally without ornament. There were two styles. One comprised a long over-garment and scarf, sometimes with a thin covering for the face and sometimes without. The other comprised two pieces: a skirt top gathered at the waistline, and a top completely covering head and shoulders and again gathered at the waistline, while the face covering could come up or down as the situation required. Both versions reflected the influence of the Turkish outer garment. In contrast to the village over-garment, which offered a colourful display of the art of embroidery, the city and small-town style was generally drab and colourless, with only a small part of it amenable to any kind of 'haute couture'.

Embroidered costumes and repetitive replica work provided scope for displays of personal taste, and, while the design was traditionally styled and repetitive in nature, the overall pageantry added colour to the routine of everyday living. Accompanied as it was by all the various manifestations of folklore – songs, music, tales, gatherings and crafts – it exhibited peculiarities identifiable by folklorists as distinctive of Palestinian daily life, maintained through all the various prevailing political conditions.

Background cloth for embroidery

The earliest kind of cloth is hand-woven 'Ramallah cloth' from the central region of Palestine. Of a natural écru colour that whitened with

washing, and loosely woven, it was suitable for counted thread work. It was later sometimes dyed black or dark blue, and there were sometimes other dark colours used.

Other materials were hand-woven *majdal*, a wide striped cloth, and, in the south, a 'gauze cloth' resembling cheesecloth. Hand-woven linens were used in northern Palestine, and such materials as striped Syrian cloth, or *saya*, in the east.

Store-bought cloth – cottons, linens, floral and striped damasks, velvets and *ghabani* – were used later, store-bought canvas yardage being initially used over the cloth, then discarded (see below), to make the onerous task of counted thread work easier.

The dyeing of natural raw to refined silk thread skeins (see below) gave way in time to the use of coloured cotton thread (flossed and *perlé*) for greater variety in the planning of colour schemes, with different brands being tried out on an experimental basis and each woman following her personal taste. In the absence of silk thread, strands were taken from squares of woven silk material, left-over pieces that were usually put away somewhere, along with other unused material, in household trunks.

Design

Costume, as noted above, varied from region to region, and the headdress, as part of this, varied correspondingly. There were, however, general stylistic tendencies. Garments would be either of loose, straight cuts or loose cuts with side inserts for added width and comfort. Front and collar-line varied between a square and a round neckline, while sleeves were mostly straight and narrow, sometimes with wider wristlines that pointed into long triangular tube shapes hanging down the sides. The sleeves were knotted behind the back when the wearer was working or carrying children. Over-garments and long-trouser suits existed as variations in lieu of dress and matching long trousers, and non-embroidered or plain-coloured long trousers were also used beneath the costume in some coastal districts, matching the undergarment or house-dress.

Colour in thread for overwork

The selection of thread material for overwork, or embroidery, was determined by tradition. Suppliers offered a variety of silks, cottons and woollen threads, but as silk (other than homespun) became expensive or unavailable, the use of flossed or stranded thread gave way to twisted *perlé* cotton. Flossed cotton, available by colour-dye number and with a thinness making it unsuitable for canvas work, lost its popularity except for table linens and counted thread work.

The typical embroideress, having no wish to see her work fade, shrink or lose its design lines, devoted special care to the choice of material. Threads were mainly as follows:

1. Vegetable-dyed and spice-dyed silks.
2. Gold and silver thread for Bethlehem work (see the section on stitchery below).
3. Twisted *perlé* cottons used in traditional colour schemes.

Colour schemes were traditionally: dark-to-bright red, with black combination on a natural background, in the Ramallah area; muted-to-bright pastels on black around Jerusalem; silver and gold embossed on a black, navy blue or wine background in Bethlehem; straw-coloured on a brown background in the Jaffa area; pale pastel silks in northern Palestine; and little or no embroidery on a printed or striped background around Nablus. The south was characterized by bright colours on a plain or muted-shadowy, wide-striped, hand-woven *majdal*, or gauze cloth, while the bedouin wore all-black with decoration provided mainly by jewellery rather than embroidery, though some edging or coloured piping was traditionally used. The choice of colour scheme reflected both tradition and personal taste. Overall, schemes were marked by pale pastels in the north, by straw colours and brownish reds along the central coastline, and by red as a basic colour in the central region round Jerusalem, becoming bright to very bright in the south. All-blue embroidered garments were apparently only worn by women in mourning, to mark a gradual return to colour following a period of wearing total black.[1]

Stitchery

The types of stitch were as follows:

1. Cross-stitch.
2. Twisted overwork couching stitch, used as a variation for Bethlehem work.
3. Daisychain-stitch in silver or gold thread; long-armed cross-stitch; satin-stitch, and other decorative finishing touches.
4. Appliqué work, attached in some cases to various costume parts, to shoulder strips or along the sides for instance, and using cut-outs and button-hole stitchery techniques to effect the attachment. Occasionally damask floral designs, lace materials and printed material as patchwork from left-over pieces of undergarment were used as see-through decoration over an original plain-cloth background. Strips from cut-outs were temporarily discarded, then later used as stuffing for padded headdresses or cushions, or else made into rag-toys. Thread, cloth, left-overs, etc were constantly recycled or stored.
5. Various finishing stitchery techniques, some traditional, others innovative, used for neatness of finish.

Technique

Embroidery was, for ease of handling, worked out on dress pieces which were then sewn together. Various methods were used to produce quantities of embroidery for costume purposes:

1. The counted thread method, two-by-two for finer lines or one-by-one on heavier, loosely woven cottons.
2. The canvas-over-cloth method, involving basting the canvas over the material, then embroidering through the material, after which the canvas would be pulled out thread by thread and discarded. Canvas was generally a penelope style of double thread.
3. Later techniques of machine embroidery and machine stitching, favoured for their practicality and lower cost. This usually involved dressmaking rather than genuine embroidery

techniques, with a greater element of commercialization. Artistically, the final product bears no comparison with earlier hand-embroidered costumes.

Finishing touches and clothing care

Handmade 'scythes' in multicoloured satin-stitch counterchange were used to cover side seams. There were also decorative edgings, added shoulder strips, appliqué work, simple long-armed cross-stitch work, or running stitch, using embroidery thread (for wear-and-tear duty) in preference to machine stitching in sewing pieces together. Older costumes used left-over thread for hemming, etc, and some costumes would be repieced from several different costumes with the worn-out panels discarded.

Costumes used for daily or occasional wear were kept in trunks or hung in the wardrobes that came with setting up home. They were put through daily, weekly or monthly washing procedures, using homemade olive-oil soap and water, then hung out to dry in the sun in summer or indoors in winter. In low-income groups, costumes were normally hung on temporary clothes lines attached to trees before being collected in the evening, sometimes aired, then stored. Exact washing-day procedures would naturally be determined by such things as the number of children in the house, the availability of space and the particular weather conditions. Costumes were easily identifiable as an individual's personal property.

CHAPTER 5

Embroidery as a Folk Art

Traditional Palestinian folk embroidery was an art, with the various patterns, colour schemes and types of stitchery passed down through the generations. It filled an artistic need, and added a feminine touch to otherwise drab garments. Older village women taught the younger ones, who in turn passed on the art to their daughters.

Village women were confined to life within the home and family unit, their menfolk acting as providers. The head of the family or clan would supply the material for general clothing needs, and the men not only admired the women's work on costumes but encouraged them to find time to sit and embroider when the routine chores were completed. The tasks assigned to women in house and field were in fact quite onerous, though in small village communities made up of families and neighbours, socialization while at work eased the burden.

Embroidery was carried out in the afternoon or early evening, when the day's work was over. While keeping a simultaneous eye on the children playing in the courtyards, the women would gather and compare patterns as they worked their stitchery, choosing shady or sunny spots according to the weather. In winter they would embroider together round a coal fire, by the light of kerosene lamps.

A married woman's first collection of costumes usually formed

part of the trousseau that had to be completed before her marriage. Village weddings were part of a family's social life, and preparation of the bride's requirements kept people busy. An engaged girl usually displayed her trousseau at her father's home, where, for several nights before the wedding, refreshments would be served and compliments exchanged (there were also, by mutual agreement between the parties concerned, wedding and post-wedding ceremonies in which custom again played a dominant part). A girl's trousseau was in fact begun, with her parents' agreement, soon after her birth. By the time she was old enough to thread a needle, she would be given a practice piece of silk or cotton thread, cloth and canvas and taught to embroider, such efforts sometimes starting as early as ten years old.

Girls did not, however, wear embroidered costumes until they were old enough to grow into them. They usually wore cotton-printed or striped kaftan-like dresses, standardized according to the geographical location of their village and styled along the lines of the undergarments worn by older women beneath their embroidered costumes. These undergarments additionally served as house-dresses while working indoors.

Costumes would be worn when out of the house – while tending sheep, goats, cattle and poultry in the courtyard, for example, or providing meals or additional help for the men in the fields, or gathering vegetables or firewood for cooking. The ovens used for baking bread or roasting fowl, along with the kerosene or wood stoves for boiling meat and vegetables and other cooking apparatus, were usually put in sheltered places outside, with extra small kitchen and bathroom areas supplied by shacks, and it was considered in poor taste for a woman to be seen in her house-dress in such places outside the house itself. The older village women would superintend the upbringing of girls in such matters.

Few village homes had running water; yet, for the normal, religiously inclined Muslim family, water was of fundamental importance. Thus providing water for ablutions, as well as for drinking, was an additional duty, and water-carrying from any available source was a common rural sight. It also, typically, provided an opportunity for the display of costume. Groups of women of all ages would sing ditty-type folk songs while gathered round local springs, helping one another set the water jugs on their heads.

Costumes were, then, a part of daily wear for village women rather

than something reserved for occasional use; and, as such, the women needed several of them. The exact number of costumes a girl prepared was an indication of her socio-economic status, and quality too was a matter for competition, the women vying with one another to produce beautiful garments. This naturally led to a fostering of technical agility and artistic achievement.

As we have seen, the influences leading to the adoption of village motif styles and techniques in particular regions and neighbourhoods did not correspond to the historical administrative divisions. Though such divisions were in fact fairly distinct both during the later years of the Ottoman regime and in the early years of the British mandate, along with the accompanying transitional period, differences in the selection and exploitation of motifs continued to exist along traditional lines. Styles remained distinctive and identifiable, with a woman's regional origin still apparent from her dress.

Nevertheless, outside influences also had an impact. The Ottoman empire, though in decline, remained formally in power until 1917. European countries also pioneered various enterprises, with politico-military missions, such as that under General Allenby, being among the first to arrive. Such missions, along with others of an educational, medical and social-welfare nature, could not fail to have an influence, whether direct or indirect, on Palestinian embroidery. There was a technical improvement, for instance, in the quality of embroidery tools, cloth and embroidery thread.

Apart from the earlier Byzantine influence on the silk trade (see the Chronology), it is clear that Ottoman Turkey exerted an influence on Palestinian embroidery techniques, and one that did not end with its dissolution in 1917. The city of Istanbul remained an important centre for acquiring pieces, and these could be a source for the adoption or adaptation of distinctive Islamic motifs and of particular finishing techniques. The heavy use of silk and gold thread, for example, reflects historical Turkish influence.

Other major influences were German, French, British, Italian and American, exerted either through mission schools in the cities or through settlers offering a variety of services to villagers. Groups of those representing European culture settled in self-styled 'colonies' in the towns and established themselves around biblical sites. They left their mark in the form of religious buildings, charitable organizations and so on, and, in the process, made their contribution to embroidery

too, as Central European Balkan-Slavic tendencies found their way into Palestinian domestic costume.

The population of Palestine was largely Muslim, and Christian missions, needing funds to carry out their work more effectively, often sought to attract the interest of Muslim officials and families, particularly where these were in a position to pay for the services provided and so subsidize basic mission work.

A number of specific influences can be cited. A major one was provided by the Germans, who settled early in the region and (except during the two world wars, when their presence in Palestine was restricted) were active in opening wool and embroidery thread outlets, bringing all the necessary domestic materials and techniques with them. Knitting established itself, yet, in embroidery, the original vegetable- and spice-dyed silks were not replaced by the wool thread the Europeans sometimes used. Costume embroidery using wool thread would simply have made garments too bulky and artistically crude; and since such items as cushions were made from worn-out costumes in any case, there was no demand from villages for embroidery wool for these purposes either. Nor was fine wool thread adopted for such things as crewel work. The use of wool was restricted to the weaving of rugs, the making of men's *abas* (long cloaks) and for knitting.

French culture, for its part, brought fine arts designs and cotton thread into modernized village life, while the British missions taught standardized everyday usage of material in the form of simple cross-stitch work, along with teaching such other handicrafts as basket-weaving, pottery work, glassware, and so on. The Americans were either residents, members of Quaker missions or Palestinian Arab Americans returning on a temporary or permanent basis. They often acquired pieces of embroidery for home display and organized bazaars, and they also initiated community embroidery projects or workshops and engaged in the buying and selling of souvenirs for tourists, so turning ancient artisanship into profitable business. They paid the highest prices for religious objects and souvenirs of lesser importance. Italians, Russians and others, who taught music and drawing and also built monasteries and churches, took an interest in religious ornament and decorated their homes with embroidery along with other craft products.

The Arab Muslim and Christian communities in Palestine were

always prepared to accept and copy one another's motifs, along with finishing touches and other ideas. Even those motifs with specific religious significance were exchanged. Then later, as motifs began to overlap in the various regions, exchanges of full costume took place as women began to dress according to personal taste rather than geographical area.

Further, minor influences were reflected in the way designs from Europe (both Eastern and Western), the Far East and Persia became accepted as a source of improvisation on original motifs. Political refugees of a religious inclination, from Central Asia and the Balkan peninsula, settled with what was left of their families and integrated into the community, retaining or discarding their own particular costume pageantry in the years that followed. While the West Europeans tended to remain in their quarters, intermarrying only in the odd individual case, the attitude of mid-Europeans was less conservative, and Eastern Europeans abandoned their initial reluctance to marry outside the group, settling down in Arabic-speaking communities and even taking Arabic names. Basic religious beliefs were retained, but customs and traditions became intermingled.

Palestinian Jews, on the other hand, remained isolated as a religiously oriented community with strict rules against intermarriage. Where Jewish women did marry Muslim men, they were allowed to retain their beliefs and practices, but were required to allow their children to be brought up according to Muslim tradition. Jewish women who married Christians, on the other hand, had to be baptized before marriage and have their children baptized too. Jewish rabbinical attitudes to family relationships stipulated the Judaization of husband and offspring in the case of such mixed marriages; and to this day the children of a Jewish woman are regarded as being of the Jewish faith.

The provision of schools and better education generally within villages (or at least the availability of these to village communities) led to an improvement in the quality of embroidery techniques. Though Christian districts like those centred on Ramallah, Bethlehem, Beit Jala, Nazareth, Tiberias and some areas around Nablus had the reputation of being quite traditional in matters of costume, they showed more foresight than their Muslim counterparts where the education of women was concerned, and Christian parents were

among the first to make use of mission schools, giving girls access to greater handwork skills, better stitchery, and so on (one may also assume it was much easier for them to accept new ways promulgated by those of their own religion). Muslim parents needed more persuasion to have their daughters educated, and did not always take kindly to the idea of sending them to day schools or boarding schools where home supervision would be diminished; besides which Christian schools also held compulsory classes in religious education. Muslim families therefore often turned to Muslim community schools or state schools run by the government of Palestine. However, although varieties and variations of handwork were taught, cross-stitch as a folk art remained something handed down, transmitted by memory and chosen according to appellation, or through copying of old costumes borrowed from friendly relatives and neighbours.

In fact, village women continued to embroider; embroidered costumes were regarded as something of value for life, and the notion of discarding such handwork was not favoured. Pieces continued to be taken or cut from old costumes to be sewn on to new cloth, then, as the new costumes wore out in their turn, put to other purposes, practical or decorative, in the house. The front parts, from neckline to waist for instance, might be made into cushion covers and side branch panels sewn together to make long reclining pads, while tablecloths, runners, napkins and towels would be individually made, along with various decorative objects like covers for bottles holding kohl, or scented flower water, or the concentrated rose water used as a village cosmetic.

Everything seemed to have an artistic or practical use, and the more daughters there were in the house the more embroidery projects multiplied. Village women were always ready for pageantry: communal social gatherings were very common, as was, to some extent, the sharing of food in the late afternoon or evening. Occasions like marriages, childbirth, the circumcision of boys, the award of a school or higher-education qualification, a promotion, a good crop season – all these meant pageantry in the village.

It is said that when a marriage was arranged, the prospective mother-in-law would ask to see a young girl's embroidery before agreeing to consider her as a bride. Other female members of the family – aunts, sisters, cousins, and so on – would often be called on to help in the assessment of, among other things, the prospective

bride's embroidery skills. Sometimes, indeed, the girl's agility in the field would be a major factor when coming to a decision. Needless to say, a small number of girls approaching womanhood could not or would not learn to embroider. Lack of patience, bad taste in the choice of colours, inability to organize and sort embroidery threads might all lead to poor artistic accomplishment. Such women were looked on as unfortunate and had to rely on other village women to make their costumes for them. Since this was a costly procedure, the average man would think twice before marrying a woman who might spend large sums in this way, and his family would be likely to try and dissuade him too. Finally, a girl who had not learned to embroider by early puberty was regarded as lacking the qualities necessary in a good wife and mother.

Preparation of a trousseau meant the acquisition of several costumes to be paraded and worn through the wedding ceremonies, the size, cost and quality of the trousseau naturally varying with the family's wealth and status. This in turn was not always stable, since agricultural villages were highly dependent on the vagaries of the weather and good crops were not always in the power of the average farmer. When the crop was a good one, it was customary to start thinking of marriage and raising families, with the resultant income determining what a future husband could be expected to contribute to the marriage settlement. This is still traditional practice in a number of Middle Eastern countries.

The settlement determined those items, such as gold pieces, that might be added to the original trousseau. Marriages between local families or neighbours were favoured, but there was also much inter-village selection, and marriages of the latter kind naturally led to an overlapping in traditional patterns and motifs. New brides would bring their own wardrobes and colourful chests, and the village home displays would begin. Visits to the new couple's quarters, whether in the original family home or in a home of their own, meant exposure to different motifs, styles and colour schemes from other areas; and the copying of new motifs, usually in an assigned order, would enlarge the choice of local women. It became customary, in the average trousseau, to include at least one piece of Bethlehem velvet work. Women would need silks, better cottons, smoother velvets and *perlé* twisted cotton colours, and would search for these outside the village, in city stores where the choice was wide and materials could be bought for both quality and quantity.

In practice, though, the onerous day-to-day routine of the average villager meant limited access to cities or nearby town market-places, and women sometimes therefore preferred to buy in bulk. Materials might be bought while visiting relatives, or while out selling farm produce, or when family members went into the town or city. Most village women were markedly industrious and had usually started planning their next costume before completing the one they had in hand.

As time went on, and technology brought electricity, fresh water and better farming implements to the villages, sewing-machines sometimes became part of the trousseau, so that the rural wife became almost more of a seamstress than an embroideress. Intricate machine-embroidery stitchery brought variety and ease to costume-making, along with speedier completion.

At the same time, the new fashion for machine sewing led to carelessness in the finishing touches of costume work. The average village woman, while having no wish to give up her costumes for the Western clothing worn by city women, also saw the sewing-machine as a practical means of making men's and children's clothing. Items such as tablecloths, bed sheets, towels and even undergarments could also be made if the woman was agile in handling the various micro-attachments. Thus the sewing-machine came to be seen as a potential source of income in the case of family loss or bereavement,[1] a financial alternative to such other sources as selling produce or dairy products from door to door, or – least favoured of all – domestic service in town or city homes on a paid daily basis. With the machine, a woman would be able to work while keeping an eye on her home and children, or fill in spare hours, or, if the income was not needed by her family, buy more gold pieces.

All this was not without its disadvantages, reflected in various shoddy exhibitions of costumes and other wearing apparel (in fact, after 1948, many original costumes were abandoned, bartered or sold). Handwork became commercial, and those women who still embroidered turned the art into a profession, sitting in an assortment of plain or printed cotton dresses or machine-embroidered costumes, at home or in embroidery workshops, turning out articles for the city-dweller and tourist to buy. Few authentic costumes were now produced, and those available for sale in outlets or tourist souqs had very little embroidery compared to those made for the trousseaux of

earlier days. Moreover, what was available was usually considered substandard. Quite simply, women embroidered for others to wear; in consequence, the motifs also varied in accordance with the dictates of the market.

In time, though, better costumes and embroidery returned, as modern Palestinian women – seeing older pageantry models that had been preserved or were in some of their own family collections as samplers – felt inclined to wear such costumes once again. It became common for such women, along with college students and young people in general, to wear 'folkloric' costumes at group folklore exhibitions or work in charity bazaars. They would also display such garments at coffee parties or at 'Palestinian nights', open-house occasions where dinner would be served and Palestinians would have the chance to meet other local Palestinians at home or abroad. Embroidery in costume and home decor became a small reminder, for expatriates, of a home and a country they had left behind.

Present-day workshops produce a variety (ranging from quasi-traditional to pop art in style) of contemporary costumes, cushions, table runners, table linen, dinner sets, hand towels, bookmarks and, recently, wedding satchels for bonbons. Both quality and quantity are variable, with colour schemes organized by whoever happens to be in charge. Motifs, using different threads on a variety of backgrounds, range from traditional village symbolism to modern emblems, maps, excerpts from the Quran and lines simply reflecting individual choice. The symbols adopted occasionally verge on the absurd. Work is still carried on in or around the camp areas, in workshops or from home on a commission basis, but the on-consignment volunteer outlets which were once found (such outlets existed for several years in Amman in the early 1950s), and which provided incentives towards a better product – prices being set according to the quality of the work – are now notable by their absence.

Present-day embroidery outlets are managed by Palestinian associations, the United Nations Relief and Works Agency (UNRWA), societies under the aegis of the ministries of social welfare, volunteer committees, women's organizations, philanthropic societies, and so on. Their activities may be supervised by UN regulations, host country laws, the Palestinian authorities, or simply by small community committees reporting informally at private coffee parties. Prices normally reflect supply and demand, and can be very high, but little

attention is paid to wages. Occasionally prices have been set too high, and during some of the travelling exhibitions the Palestinian supervising committees have been told that the costumes exhibited were simply too expensive to sell and could only be used as gifts or exchanged for something of equal value. Costumes worn by air hostesses abroad were bought by the organization they represented, while others were on loan from private collections, and folk song or dance groups used them for productions on stage.

Nevertheless, Palestinians in the Israeli-occupied territories and Jordanian refugee camps have continued to use such costumes for daily wear, and they can also sometimes be seen in refugee camps in Syria. In Lebanon, on the other hand, they have been discarded for daily use, though they are still seen for the occasional folk display. Old costumes are also preserved in valuable private collections, but there is no single public folk institute with sufficient funds to buy whatever comes up for sale in various countries. Thus, while costumes are dispersed and displayed throughout the world, those most worth preserving are not to be found in a single place. It might be added that Palestinian committees are, in the author's experience, more interested in commercial exploitation than in the enhancement of their collections through judicious acquisition.

CHAPTER 6

Developments in Embroidery Skills

Throughout history man has applied himself to improving his surroundings, whether through originality and new ideas, or through the improvisation of ideas in the context of cultural exchange, or through straightforward imitation. This applies in the art of embroidery as in any other.

By 1948 cotton twisted coloured thread had replaced silks that needed to be reeled and dyed. Steel needles of all types and sizes could be bought by the unit. Material and textiles no longer had to be homespun. Finally, the sewing-machine had come to occupy a crucial place in the home, making all the finishing touches and stages of making up a costume that much easier.

Skills had by now become scarce, which meant that the skilled embroideress/seamstress could start to earn a living by doing finishing-up work for her neighbours. We should also remember, in this context, that Palestinian embroidered costume was worn not only by women and girls over the age of ten in the villages themselves, but by those whose living took them from the villages to the neighbouring towns. Whether costumes were ornate for occasional wear or simple for everyday work, many homes now paid to have them made. Resort would be had, in the first instance, to local women: the wives, sisters

or daughters of friends or relatives in the clan. Then, if the particular item ordered could not be produced in these circles, the request would be passed to the neighbouring villages.

Generally, as we have seen, a stock of materials was constantly available in the home; there would be an assortment of textiles, canvas, thread, needles, tape measures and a pair of scissors, with anything that could not be made at home being brought in from town by a male family member. New ideas were beginning to take hold of the average family, with costume work becoming as important as the provision of food. Women would, in fact, plan the food in the mornings, see to the children and take the men their lunch in the fields, then settle down in the afternoon to make costumes.

By the end of the 1930s, it will be recalled, embroidery formed part of the teaching for young girls in sewing or art classes in the schools set up in towns. Various types of stitches were taught, though there was less emphasis on cross-stitch than on other auxiliary needlework stitches. Much depended on the type of school attended. As for the villages themselves, attempts were already being made to involve women in small sewing circles, with instruction given either by a local woman or by an interested guest of honour.

The women who were now commissioning costumes still chose the materials and textiles, the colour, cut and planning of motifs, and those executing the commission needed to become skilled in assessing their charges, which represented an important addition to the family income. The menfolk had no objection to the women's undertaking paid embroidery or sewing work, provided this did not take them out of, or too far from, the family home.

Skilled women were the first to be invited to supervise the workshops that began to spring up in the era of dispersion following 1948, and those giving instruction in the ordinary sewing circles now had a wider professional outlet. This is one reason not to underestimate the importance of skill-building in the embroidery business of more recent years – it was actually a form of career training.

Although skills were, at this time, a source of aesthetic pride, there seems to have been considerable family influence on tastes. Skills were largely self-motivated, with the recognition traditionally enjoyed, the admiration of viewers and the financial rewards and fringe benefits all combining to promote higher skills. However, whereas early skills were developed at home, in the context of family relationships,

comparison with work produced outside the family circle later led to a degree of standardization.

By the late 1930s and early 1940s this art-turned-craft demanded the use of new implements. Tourists had started to take an interest in buying second-hand embroidered costumes – if not the dress itself, then the jackets, coats or boleros, along with besilvered accessories like the headdress and shawl – and the more elaborate whole or partial costumes were, the higher price they fetched. It was already common knowledge that particular artisan goods could be bought more cheaply in the geographical areas where they were traditionally made. The north could offer simple counted thread costumes in hand-woven linen, while Nablus and Jenin had plain, shiny Syrian *saya* with little or no embroidery. The coastline had various bright colours. The Ramallah district close to Jerusalem wove its own 'Ramallah cloth', while Bethlehem provided overlaid metallic costumes and jackets. As for the desert bedouin in the south, they had a profusion of embroidered articles, though garments were simpler in the Jordan river basin. The south had its own textile industry, weaving *majdal* cloth and rugs, and around Jerusalem there was a mixture of imported Syrian *ghabani* textiles and embroidery for ornate occasions like weddings and feasts. Tourists and resident foreigners started photographing or painting the most attractive costumes, with attention focused on the colour aspect. Meanwhile silk costumes, and silk thread, were growing scarce.

Since patterns were exchanged from memory, the essential skills involved in recalling, executing and preserving a particular model put further pressure on the embroideress. There was no equivalent of the vast number of manuals, hobby ideas, short or long courses and open-house visits available today. Now, at the end of the twentieth century, publishers all over the world are flooding the market with embroidery skills books, many even specializing in rare or hard-to-find titles. This encourages the improvement of skills in areas where such works are able to circulate – a far cry from the few periodicals and worn-out leaflets circulating among women whose level of literacy would not, in any case, have allowed them to profit from books with an elaborate text.

Present-day stitchery magazines have specialized cross-stitch features, including sketches, photographs, diagrams and graphs, black and white or coloured – nothing is left to the imagination. Under various headings, practical sections give instructions on starting a

piece of work, on the amount of thread needed for designs, on cross-stitch and back-stitch (using embroidery hoops), on mounting and framing (using metallic blending filament with multiple choices of thread), on washing and pressing, on how to mitre corners, and so on – to say nothing of endless specialist addresses and advertisements. It is no longer necessary to wait for thread and material to be collected and home spun, worked on, then finished. Also, there is almost no wastage of material, and therefore no possibility of making all kinds of articles from left-over remnants.

It is a fact, to my personal knowledge, that this technology and rapid circulation of new ideas have not yet reached most present-day Palestinians; and it is vital, these days, to see embroidery not only in a cultural context, in terms of preserving and reviving an ancient heritage, but from the viewpoint of building up a social infrastructure that can (in conjunction, obviously, with other skills) benefit millions of Palestinian homes everywhere.

On the other hand, a mere concentration on quantity, with no effort made to improve quality, will mean innovation at the cost of a heritage that once found expression in satisfying a market demand for handmade products. With this in mind I set out to establish a national collection, however small, from which prototypes could be circulated to embroidery workshops, circles, outlets, etc, so as to relieve the pressure on memory alone to keep a candle burning in the window. I have had the pleasure of discussing, with various women, ways of keeping this and other old crafts alive, and it is hoped that a later, comprehensive work on other crafts will give due credit to these people, who have devoted such endless time to committees, organizations, exhibitions and wide marketing of their work in an attempt to aid Palestinian refugee women. Others have shown their initiative by setting up their own small-scale workshops for folk industries, and a questionnaire presently circulating should, I hope, yield significant data in due course.

Meanwhile, displays in national museums, and through national outlets and private collections, might help re-educate various nations, with various backgrounds, in the values of a culture they have grown up with through the ages. At present (see Appendix I on the assessment of fieldwork) we all too often see the dumping of cheaper articles, with blurred motif designs, on an already saturated market. Further data concerning the state of the craft market, supplementing

that already collected (see the same appendix), might help to introduce ideas appropriate to the twenty-first century.

Will the headaches of location and relocation, and all the new priorities in the era of self-government, allow scope for constructive progress towards better products and a more effective preservation of folk culture? Let us hope so. Yet if such progress is not forthcoming, we can at least content ourselves with the thought that skills in embroidery and the embroidered arts have brought an element of aesthetic meaning into so many homes.

PART III

MOTIFS IN CROSS-STITCH WORK UP TO 1948

Gate entrance to an old house built in Jerusalem in 1790; Palestine Arab Folklore Centre Museum, Jerusalem (photograph courtesy of the museum).

Inside hall of the Palestine Arab Folklore Centre Museum, 1980 (photograph courtesy of the museum).

Jerusalem bridal city costume in the Turkish style of the 1890s (photograph courtesy of the Palestine Arab Folklore Centre Museum).

Bedouin bridal costume from Khan Yunis, early twentieth century (photograph courtesy of the Palestine Arab Folklore Centre Museum).

Bahia Mardini Khalifeh in traditional city cape/coat, Jerusalem, 1930 (?) (photograph: John Krikorian).

Amira Hamed in contemporary costume, bazaar for the benefit of the Society for Martyrs and Detainees, Amman, 1990.

Amira Hamed and others in contemporary costumes, bazaar for the benefit of the Society for Martyrs and Detainees, Amman, 1990.

Itidal Mahmud in contemporary Ramallah costume, Amman, 1996.

CHAPTER 7

The Origins of Cross-stitch Motifs

According to historians of artisanship and collectors of artefacts, the use of cross-stitch work in embroidery has its early origins in Chinese craftsmanship, whence it moved first to India, then to Egypt, then to Greece or Rome – though sewing, weaving and textiles, going back millennia, naturally precede specific stitchery. Needlework used a variety of early implements, along with a selection of materials supplementing skins and furs, before hair and thread were woven into a form of textile for daily use and protective cover. Embroidery, however, specifically refers to the decoration and ornamentation of plain textiles, with terms like needlework, needlepoint, tapestry, counted thread work and canvas work sometimes used in an overlapping way.

There are various forms of cross-stitch, but the principle is the same in each case: the aim is to decorate the surface of a loosely woven fabric, partly or wholly, by means of consistent stitchery. Used for adorning religious edifices, household items or costumes, cross-stitch, along with other forms of elaborate needlework, evolved over the centuries.

China was a source of embroidered articles as early as the second century AD, and fragments of textile and embroidery are preserved in archaeological remains. We may also assume that the Greeks knew of

embroidery and encouraged it. Nevertheless, the earliest surviving fragments of all are of South American Indian origin dating to the fifth century BC, along with a single Greek fragment from the same period. Early Russian ornamental sewing has also been discovered in frozen tombs.

Later evidence, however, cannot be traced further back than the Middle Ages. In Western Europe the earliest remnant is an English piece found at Maeseyck in Belgium. Embroidered pieces of this period are rare, since embroidery was then practised or commissioned for occasional use and could not at this time be considered a folk art.

In the Middle Ages, it was fashionable for samplers to be worked as a means of practising stitchery. These might be begun at a very early age, with cross-stitch used, for example, to embroider an alphabet as part of the process of learning to read. Later, traditional forms and techniques came to be influenced by new materials and other crafts.

Cross-stitch work was practised in both convents and homes, and traditional colour combinations began to be established. In fourteenth-century Burgundy, work reached a peak of perfection. Then cross-stitch work underwent a period of total eclipse, becoming a peasant craft – practised by peasants in Italy, Swabia, the Rhineland, the Netherlands, Hungary, the Balkans, Transylvania, Yugoslavia, Austria and Romania – and ignored by the cultured. Only in the first half of the nineteenth century was it once more prized for its beauty.

Tent-stitch, or half-cross, was used as a filler and was sometimes worked throughout the embroidered article. Silk and wool would be used over a variety of backgrounds to embroider stylized or semi-stylized symbolic motifs, which might be natural, floral, mythological or religious in nature.

The motifs combined realism and fantasy, and pattern books started to become available, though they were still rare items. Comparing patterns designed and embroidered in different parts of the world, we find similarities in the patterns themselves but differences in the names applied to them. Europe assimilated a variety of new motifs as Persian carpets became popular there. Whether using coarse wool or fine silk for decorating household furnishings such as hangings, upholstery or rugs, people now found that cross-stitch reinforced tent-stitch, giving a more durable appearance and minimizing its diagonal warping.

Cross-stitch – the main stitch employed in Palestinian embroidery – was used, along with a variety of other decorative stitches, in many

other national embroideries throughout the world. Once more, as it regained popularity in the nineteenth century, samplers in the stitch were produced on loosely woven material, but the use of wool and coarser openings in the fabric meant that such work (of which Berlin work is an example) became less delicate.

It should be stressed once again that, though various motifs date back ultimately to early symbols in archetypes and prototypes of architecture or painting, their use on embroidery can only in rare cases be traced to very early beginnings. Commonly found motifs in cross-stitch work, especially on costumes, are the carnation, tulip, rose, pomegranate, peacock, dragon, fern frond, oak leaf, pigeon, snail, candle and candlestick, star, cone and heart. All of these are still in use as folk motifs in Palestinian embroidery, along with such religious symbols (ultimately Hellenistic and Roman in origin) as the Holy Star or Cross of Jerusalem and Bethlehem, the Holy Keys of Jerusalem and Hebron, the Gates of Heaven, the Guardian Angels, the Tree of Life, the Holy 'S' Serpent, the Trefoil and the Syrian Inhabited Scroll.

Cross-stitch motifs commonly exhibit key symbols with a definite lineage. These key motifs, later charted and named, and usually having a basis in early Chinese dynastic roots (see the Chronology), are the subject of familiar appellations in folklore and folk art.

As for lines, these may be curvilinear (as in the case of early Christian Holy Land symbols), rectangular (as in Roman or Hellenistic architecture), square or triangular or circular, floral (as in early Persian forms), arabesque (as in Islamic art) or stylized (as in Norman to Italian Renaissance work).

Many symbols are recorded in early inscriptions, woodcuts and workbooks, and Venice, Nuremberg and Paris issued charted publications as early as the sixteenth century. They were applied in the form of counterchange, with colours, motifs, background or design alternately reversed, as in the Assisi work based on models brought back from the Crusades in the Holy Land. This counterchange exhibited an interplay of early Holy Land geometric style with naturalistic Far Eastern forms (see Chapter 2). The result provides a practical record of amalgamated nature and civilization, mediated through the fingers of women who were never, throughout the ages, permitted to be idle – few of the embroidered articles can be attributed to male hands.

The use of cross-stitch work, as currently displayed in museums,

sold in shops, worn as costume or used for household furnishing, may be found in the following areas of the world:

1. In Latin America and Mexico, among Hispanic Indians in Ecuador, Peru and Bolivia, and in such Europe-oriented regions as Chile, Argentina, Uruguay and southern Brazil.
2. In North America, both among Americans of European origin and among native American Indians.
3. In Europe, in Scandinavia, Iceland, Lappland, Finland, Britain, the Netherlands, France, Spain, Italy, Austria, Germany, Switzerland, throughout the Balkan peninsula, Yugoslavia, Bulgaria, Greece, trans-Danubia and Poland, the Baltic and Caucasian parts of the former Soviet Union, Armenia, Ukraine, Turkestan, Uzbekistan and Siberia.
4. In the eastern Mediterranean, in Palestine, Lebanon, Syria, Jordan, Egypt and (though less prolifically) in the Arabian peninsula.
5. In Africa, both in North Africa and in the sub-Saharan regions.
6. In central parts of Asia, in and around India (though not widely), and in Iran, Afghanistan and Turkey (though here again, cross-stitch is not a major feature of artistic embellishment, the emphasis being more on wool rugs and overwork).
7. Throughout South-East Asia, which – probably influenced by China – has produced the most minutely detailed cross-stitch work, using silk thread on a gossamer background. China itself, which initiated the art, unquestionably set world standards for the perfection of work in cross-stitch and half-cross-stitch accompanied by artistry in the use of colour, detail and symbol. Symbolism was of considerable importance to the Chinese, and motifs had precise meanings, which changed, along with the names, as they passed along the trade routes and through other channels of migration, becoming associated with different traditional beliefs and customs. In this way cross-stitch, which is repetitive in nature, became the vehicle for various inscribed forms and acquired meaning and language, the motifs chosen giving interest and general significance to the embroidered article. No longer used as a mere filler stitch, but to carry various sets of symbols with detailed individual variations, it served to carry pictures and ideas from one region of the world to another.

In the context of symbolic change and the adoption of new motifs, it is clear that Palestinian art – with Palestinians subject to geographical restrictions in their own homeland and widely dispersed elsewhere – poses particular problems for those attempting to collect, record and assess contemporary and future work. Yet despite all the different locations and all the different names in use, the Palestinian woman is still using a needle, a thread, a canvas, and perhaps a charted sketch, to cross-stitch her life story.

CHAPTER 8

Motif Selection

Women in Palestine believed in the personal acquisition of decorative material objects, not simply with regard to wearing apparel but in all aspects of life. Islam granted women the right to own property, and whatever wealth they inherited or managed to earn remained theirs to keep, even after marriage. Since bank accounts, shareholdings and other investments never became very common, money would be stored away, either in gold pieces or as paper money, in a safe place somewhere around the house. Even so, a married woman, who often shared her home with relatives and had rooms in a patriarchal household, was always wary of leaving paper money around: cash could be handled accidentally by her children, or might be discovered during house-cleaning, and it was not identifiable. In these circumstances women felt the need for something personalized and distinct from other women's property, which could be reported in case of theft and retrieved by the authorities.

For this reason women tended to devote any funds left over after seeing to various priorities – such as the home itself, school and higher education for their children and perhaps decorative objects for the home, like carpets, glassware and aluminium or silver cutlery – to jewellery, clothing and other movable objects. They would buy or

exchange gold pieces, coins, bracelets and chains encrusted with a few precious stones, along with blue glass or blue turquoise to ward off the evil eye. The aim was to display one's socio-economic status without, however, giving rise to jealousy.

Gold pieces in traditional symbolic forms like snakes, horseshoes, lockets, eyes and hands were second in popularity after those with religious symbolism like Qurans, inscribed Quranic verses and crosses. Amulets, in the form of a scribbled mixture of religious phrases, folded into a small package made from cloth and sewn up, then attached to clothing with a safety pin, also served to ward off evil. They were usually removed when changing or washing clothes, but never opened once sealed. Such items would be handed to loved ones, to provide protection against supernatural forces or the evil thoughts of friend or foe. Objects representing the supernatural, the fantastic or the celestial were also embroidered on to clothing.

As far as embroidered motifs were concerned, while decorative embellished touches were the fashion, the general aim was to make the object represented as close as possible to the natural. Copying was normally done either from memory or by placing the object to be copied in front of the embroiderer. Inaccuracies – quite common in hand-done work – would provide a degree of improvisation that tended to become established as re-copying occurred.

Because clothing was of prime importance, women took pains to display their personal taste, and motifs became a form of self-expression. The choice of motifs reflected a common interpretation, which was generally attributed to them, and this may well explain why most women stuck to traditional forms. They wanted to identify and be identified.

Motifs were selected for other practical purposes too, such as handmade craft objects for the household, and this minimized the chances of mix-ups or mistaken identification. Whereas literate city and town women resorted to monograms, initials and written phrases, artistic village women found pictorial motifs both personally expressive and useful as a means of identification. During social gatherings with others from the vicinity, motifs made a topic for conversation and small talk; and when, in the course of time, greater literacy among the younger generation brought in illustrated booklets and magazines, these too could be shared by the elders and provided a source for a widening of motifs.

Village women could also, in the more sophisticated handwork journals, find new or different motifs to copy. Such variations were usually labelled 'foreign' or 'strange', the Arabic word *gharīb* meaning both 'foreigner' or 'stranger' (applied to a person) and (applied to an object) 'peculiar' or 'exotic'. Such innovations would receive their proper appellation and, once adopted, would be copied and recopied – incorporated into the set of traditional motifs, but labelled as 'foreign'.

Many village women, especially those of the younger generation who had been exposed to the high-school or teacher-training education latterly available in Palestine, found 'foreign' motifs appealing. Very few of them realized that their own traditional motifs had actually travelled to the ends of the earth, been adopted and copied (with appropriate variations), then migrated back to them as 'foreign' symbols. This might perhaps provide an explanation of the admiration expressed by present-day tourists, travellers and pilgrims for Palestinian embroidery in costume and other articles. Perhaps all the different people, seeing these items offered for sale, are reminded of their own roots and their own particular traditions, recalling the sight of their mothers and grandmothers settling down for the evening in an effort to finish a piece of embroidery started months before. They may remember how their mothers' trunks, which served as their personal wardrobes, contained delicate pieces of embroidery, some incomplete or discarded, others with finishing touches patiently applied.

Whatever their origins, motifs were divided into named types, and all were repetitive and counterchanged with respect to colour, stylization and application to costume. They could be categorized as follows:

1. *Units:* These were sometimes used singly and sometimes placed alongside one another. The basic form was generally square (e.g. for moon or stars), round (e.g. for rosettes) or rectangular (e.g. for the Road to Egypt, crabs, birds, and so on). Whether in reversed pairs or double, facing each other, as in the case of animals or birds, they were placed identically in the middle of the dress, either at the front or the back, as a divisional guideline for counterchange.
2. *Branches:* These were entwined mirror-image in reversed order, and might vary from wide to narrow. They could be used

alone or accompanied by borders. Counterchange is a more common descriptive term applicable to these designs.
3. *Border motifs:* These were fillers and again varied from wide to narrow. They normally accompanied units or branches to complement and work around, but could occasionally be used alone. Syrian Inhabited Scrolls, for instance, could be either borders or branches.
4. *Edgings:* These were border motifs for sleeves or additional shoulder strips worked in cross-stitch. They were sometimes added on, in chain-stitch, etc, to hemstitch or overlay, using gold or silver thread instead of silk or cotton.

Even after the motif had been selected, tradition played a part in how it was actually placed on the costume. In most cases, indeed, the location of a particular motif was already pre-selected. Costumes were embroidered while still in pieces, and certain areas of the costume were decorated with sets of motifs. Dress-front squares from neckline to waistline were covered with the main themes, such as repeated moons, an arch or birds, and various borders were added to complete and complement. As for the lower back panel of the costume, down the full length to the base, this was covered throughout with a tapestry-like design referred to as the 'carpet' or 'filling', the rectangular shape (see Appendix III) being reminiscent of a carpet, and with geometric arabesque patterns. Borders usually accompanied these to round up the front. Side panels were covered with wide branches of mirror-image entwined patterns and flanked by borders commonly known as the Baker's Wife, or by smaller geometric borders. The more dressy the costume, the more ornate was the decoration, with ordinary daily wear bearing simple patterns only.

Sleeves had branches down the middle, and decorative birds, dragons, etc, reminiscent of Chinese embroidery or Assisi work, were worked as edgings. The branch theme would commonly be carried throughout, this also applying to borders. Improvisations or variations would occur, however, given that motifs were copied from memory. It was not unusual for a woman to use her imagination to complete a design and exact duplicates were very rarely found. Imperfections, springing from the minuteness of the work involved, gave an individualistic touch to the finished item. Costume length and size also varied and it was not always easy to fit units, branches,

borders and edgings together in a precise way.

In conclusion, one may say that women wore what they believed would bring them fertility, luck and prosperity, or would remind them of their home life as they grew older. It is always reassuring to see women move into old age with dignity, finding activities to occupy them and leaving behind a legacy of traditional embroidery.

CHAPTER 9

Folk Appellation – A Charted Language

The following is a basic list of traditional folk motifs, divided by category and corresponding to the illustrations in Appendix III below. Motifs include variations, this being reflected in the total number of motifs given at the bottom of each category. An unclassified alphabetical list of motifs is provided in the same appendix.

I. Beliefs or Religious Symbols
　Amulet
　Byzantine (or Greek) Star
　Crab
　Dragon
　Eyes
　Fountain of Life
　Gates of Heaven
　Heart
　Holy Candelabrum
　Holy Keys of Jerusalem
　Holy Mount
　Holy 'S'
　Holy Salver

Holy Star of Bethlehem
Jerusalem Cross
Key of Hebron
Mihrab (prayer niche)
Palm (of hand)
Road to Egypt
Tree of Life
Wall of Jerusalem (citadel)
(*Total: 46 motifs*)

II. Courtyards and Gardens
Carnations
Cock's Comb
Cypress Tree (*also* Tree of Life)
Damask Rose
Dragonfly (*or* Snapdragon)
Flower Pot (*or* Vase)
Flowers
Lily
Rose
Snowflakes (foliage)
Sunflower (or Garden Rose)
(*Total: 36 motifs*)

III. Field Produce
Acanthus (*or* Wheat Spear)
Apples
Cactus Fruit
Cauliflower
Chick-peas and Raisins
Corn
Fruit Tree
Grapes
Hawthorn
Mulberry
Palm Trees (short)
Palm Trees (tall)
Tomatoes
Watermelons
(*Total: 25 motifs*)

IV. *Rural Scenes*
 Arch (*or* Rainbow)
 Chinese Cloud
 Moon
 Moon and Feathers
 Moon, foreign
 Moon of Bethlehem
 Moon of Ramallah
 Syrian Inhabited Scroll
 (*Total: 25 motifs*)

V. *Animals, Real or Legendary*
 Cow's Eye
 Frogs in a Pond
 Lions (or Lion Tree)
 Scorpions
 Snails
 Snake and Serpent
 (*Total: 10 motifs*)

VI. *Birds and Fowl*
 Cock (or Rooster)
 Hoopoe
 Lovebirds
 Peacock
 Pigeons (*or* Doves)
 'Skalli' Birds
 Swan
 (*Total: 21 motifs*)

VII. *Home Life or Implements*
 Bachelor's Cushion
 Chain
 Farmer's Wife
 Ladder
 Millwheel
 Old Man's Teeth
 Pegtops
 Roundabout (*or* Baker's Wife)

Saw
Shepherd
Soap
Stick
(*Total: 28 motifs*)

VIII. Possessions or Decorative Objects
Candlestick
Crown
Feathers
Kohl Bottle
Lamps (*or* Lamplights)
Pool (*or* Harp)
(*Total: 14 motifs*)

Women's Handicraft Society shop in Roman amphitheatre, Amman, 1955.

Inside the Women's Handicraft Society shop, with ex-Queen Dina, Mrs Camille Chamoun, Leila El Khalidi and her daughter Fatima Husseini, Amman, 1955 (right to left).

Conclusion

The further I have researched into the material for this book, the more urgently I have come to feel the need for private or national collections of costumes and other embroidered artefacts to be preserved. I am also increasingly conscious that the emotions stirred in me on viewing examples of artistic folk crafts are shared by many people.

I feel, finally, that older Palestinian costumes should be viewed as museum *pièces de résistance* and, as such, treated with the respect they deserve. Moreover, whatever comes on the market for sale should be bought by an appropriate organization (along with comparable examples in other areas of Palestinian folk arts and crafts) and displayed in a national museum, with material augmented by donations from private collections.[1] This is only, after all, what other enlightened countries have been doing for years. In the case of the Palestinians, however, territorial rights have been denied, so that nothing could be effectively displayed on native soil.

Finally, the commercial aspects of the production of such artefacts should be kept under supervision, with standards set for value and quality. More workshops, equipped with better tools, could produce better handwork. Tourists to the Middle East have always been attracted to craft workshops; yet the working conditions in such places

– where the most complicated artefacts are designed and executed – have been consistently appalling. The socio-economic welfare of skilled handworkers, and the provision of more suitable working conditions for them, can only be met from within.

Some initial planning steps, in the areas of field sampling, feasibility studies and economic research, have already been undertaken with regard to Palestinian work. How these are followed up will depend on whether there is a sufficiently long Palestinian presence, in a single country, for the necessary work to be carried out. Such a complex question is, however, beyond the scope of a work on embroidery.

APPENDIX I

An Assessment of Palestinian Sample Fieldwork

Documentation is inevitably a slow process and, in the field of folk arts and crafts, involves considerable fieldwork. Handwork, of the necessary quality and in the necessary quantity to supply market needs, augments income and creates new employment on a hire basis; it cannot be achieved on a production line. Yet handworkers, skilled though they may be, are at present required to work in unsuitable conditions, while occupational hazards and disabilities may even cripple them, with the resultant loss of employment. If modern technology is unable to provide a substitute for the handwork involved, it can at least help alleviate appalling conditions by producing better raw materials for projects and better tools with which to work. It is still possible to find handwork shops in which primitive tools are used, with increased improvisation as time goes on. Some of these tools are in fact merely developments of crude ancient prototypes.

Cross-stitch work is carried on to this day in illiterate to semi-literate societies by women categorized as 'unskilled'. Women growing up in an educated or technically oriented society are increasingly finding embroidery in quantity an unappealing art when compared to the higher-status professions now open to them.

Moreover, high-quality embroidery, entailing skilled labour, has been geared towards a low-income, high-profit system, as various groups and societies set up organizations of all kinds in which embroidered artwork is commissioned and usually sold on, though sometimes also acquired for personal use by women active in such organizations or connected with those who are. So-called non-profit organizations, though philanthropic in concept, are occasionally badly run.

In the area of Palestinian folk art, there is a general reluctance (on the grounds of 'confidentiality') to provide financial records for statistical study. Middlemen and those trading on a commission basis tend to become aggressive if questioned about the feasibility of private projects, so that information depends on the availability of brochures, organizational reports and other privately printed material. Those societies, whether philanthropic or otherwise, that operate on a national level may not in practice be subject to government policies, rules and regulations. The relevant Palestinian societies model themselves on public-sector organizations of various kinds, using haphazard procedures that do not necessarily encourage documentation.

In organizations that sponsor supervised workshops, financial and business records may or may not be available – they are often lost or difficult to retrieve as a result of financial confusion, archaic methods and bureaucratic restrictions. Eventually the loss of records may lead to the disbandment of offices and workshops, or to their being shunted round from one place to another.

Even where records are available, officials block access through red tape, and this too creates obstacles to further research as pertinent material is shelved, lost or destroyed. As with the silkworm's protective cocoon, where the silk thread can only be reeled and put to use if properly handled, progress is made impossible by crude procedures. And all this is quite apart from the more justifiable reluctance on the part of businesses such as private workshops to release material for fear of this being passed on to competitors.

Yet all organizations working in the public interest, whether public or private, whether labelling themselves philanthropic or not, should keep records to which reasonable access is provided, and their organizational reports should be published and evaluated. The need for regular monitoring, whether on a daily, monthly, quarterly or annual basis, has been blissfully disregarded up to now. The

improvement of standards – or, rather, the restoration of standards previously found throughout the embroidered arts, and in other forms of folk arts and handwork too – will not be brought about by dumping large quantities of cheaper products on an increasingly demanding market. Buyers are growing ever more discerning and selective, and connoisseurs, whether large or small purchasers, cannot be fooled. Such an improvement will only come about through further consumer market research and the establishment of better commercial authorities.

Displays in national museums and other national outlets, and of private collections, can help re-educate those in various countries, with their different cultural backgrounds, as to the value of the culture they have left behind. Published joint-effort, inter-departmental cooperation will result in better products and the preservation of folk culture.

The question remains: will the Palestinians, with all their politico-military factions and the headaches of relocation, finally realize the need to cooperate in providing documentary information on specialized products (for experience teaches us that progress can only be made when we start from within)? My own quest may seem the smallest of beginnings when compared to the endless progress of civilization, and insignificant compared with the life of nations. Yet if queries such as mine are to remain unanswered, it might be better if the world leaves the silk cocoon to its own natural devices and the new airborne silk routes simply cease to exist!

APPENDIX II

A Note on Terminology and Translation

A variety of dialectal usage – which has never been the subject of a comprehensive study and whose complexities cannot all be revealed by fieldwork – means that there is no clear common terminology in the field under study. Although attempts to document colloquialisms are valuable, there is as yet no authoritative source of terms which will allow an effective process of communication.[1] Nevertheless, a degree of uniformity is obviously desirable for scholarly and library purposes, if only to encourage clarity and provide a proper frame-work for researchers.

As such, a simplification of folk terminology is highly desirable. Folk terminology is colloquial and, while translation may be useful, it does not always provide an adequate rendering – for effective translation depends, finally, on the translator's ability to find one commonly accepted term in a variety of contexts, which may not always be possible.

APPENDIX III

Folk Appellations, 1948: An Alphabetical Listing

Computerized designs by Dana Sa'ad

92 Appendix III

Acanthus (1)
Sabāleh (1)

Acanthus (2)
Sabāleh (2)

Acanthus (3)
Sabāleh (3)

Amulet (1)
Ḥijāb (1)

Amulet (2)
Ḥijāb (2)

Amulet (3)
Ḥijāb (3)

Amulet (4)
Ḥijāb (4)

Amulet (5)
Ḥijāb (5)

Apples (1)
Tiffāḥ (1)

Apples (tree) (2)
Tiffāḥ (2)

Arch (1)
Qaws or *Qalāyed* (1)

Arch (2)
Qaws or *Qalāyed* (2)

Arch (3)
Qaws or *Qalāyed* (3)

Bachelor's Cushion
Makhaddet al-aʿzab

Byzantine Star (1)
Ṣalīb al-Rūm (1)

Byzantine Star (2)
Ṣalīb al-Rūm (2)

Cactus Fruit
Ṣubbayr

Candlestick (1)
Shamʿadān (1)

Candlestick (2)
Shamʿadān (2)

Candlestick (3)
Shamʿadān (3)

Candlestick (4)
Sham'adān (4)

Carnations (1)
Qrunful (1)

Carnations (2)
Qrunful (2)

Carnations (3)
Qrunful (3)

98 ❦ Appendix III

Carnations (4)
Qrunful (4)

Carnations (5)
Qrunful (5)

Carnations (6)
Qrunful (6)

Carnations (7)
Qrunful (7)

Appendix III 99

Carnations (8)
Qrunful (8)

Cauliflower
Qarnabīṭā

Chain
Zarad

Chick-peas and Raisins (1)
Ḥummus wa-zbīb or
Ḥbūb al-barakā (1)

100 ❧ *Appendix III*

Chick-peas and Raisins (2)
Ḥummus wa-zbīb or
Ḥbūb al-barakā (2)

Chick-peas and Raisins (3)
Ḥummus wa-zbīb or
Ḥbūb al-barakā (3)

Chick-peas and Raisins (4)
Ḥummus wa-zbīb or
Ḥbūb al-barakā (4)

Chinese Cloud
Mawj al-baḥr

Appendix III ❧ 101

Cock (1)
Dīk (1)

Cock (2)
Dīk (2)

Cock's Comb (1)
'Urf al-dīk (1)

Cock's Comb (2)
'Urf al-dīk (2)

Corn (1)
Dhurā (1)

Corn (2)
Dhurā (2)

Corn (3)
Dhurā (3)

Cow's Eye
'Ayn al-baqarā

Appendix III ✣ 103

Crab
Salta'ōn

Crown
Tāj

Cypress Tree (1)
Sarū (1)

Cypress Tree (2)
Sarū (2)

104 ❧ *Appendix III*

Cypress Tree (3)
Sarū (3)

Cypress Tree (4)
Sarū (4)

Cypress Tree (5)
Sarū (5)

Cypress Tree (6)
Sarū (6)

Appendix III ❧ 105

Cypress Tree (7)
Sarū (7)

Damask Rose
Wardet al-Shām

Dragon (1)
Jān al-nār (1)

Dragon (2)
Jān al-nār (2)

106 ❧ Appendix III

Dragonfly *or* Snapdragon
Tumm al-samakeh

Eyes (1)
'Ayn (1)

Eyes (2)
'Ayn (2)

Eyes (3)
'Ayn (3)

Appendix III ❧ 107

Farmer's Wife
Fallāḥā

Feathers (1)
Rīsh (1)

Feathers (2)
Rīsh (2)

Flower Pot *or* Vase (1)
Quwwār (1)

Flower Pot *or* Vase (2)
Quwwār (2)

Flower Pot *or* Vase (3)
Quwwār (3)

Flower Pot *or* Vase (4)
Quwwār (4)

Flower Pot *or* Vase (5)
Quwwār (5)

Appendix III ✤ 109

Flowers
Ward or *Ḥannūn*

Fountain of Life
Nabʿ al-ḥayāt

Frogs in a Pond
Ḍafādeʿ fil-birkeh

Fruit Tree (1)
Shajar bi-thamar (1)

110 — Appendix III

Fruit Tree (2)
Shajar bi-thamar (2)

Gates of Heaven (1)
Bwāb al-janneh (1)

Gates of Heaven (2)
Bwāb al-janneh (2)

Gates of Heaven (3)
Bwāb al-janneh (3)

Appendix III ❧ 111

Gates of Heaven (4)
Bwāb al-janneh (4)

Grapes (1)
'Inab (1)

Grapes (2)
'Inab (2)

Grapes (3)
'Inab (3)

112 ❧ *Appendix III*

Hawthorn (1)
Zaʿrūr or *Dōm* (1)

Hawthorn (2)
Zaʿrūr or *Dōm* (2)

Heart (1)
Qalb (1)

Heart (2)
Qalb (2)

Appendix III ✤ 113

Heart (3)
Qalb (3)

Heart (4)
Qalb (4)

Holy Candelabrum (1)
Shamʿadān (1)

Holy Candelabrum (2)
Shamʿadān (2)

114 ❧ Appendix III

Holy Candelabrum (3)
Shamʿadān (3)

Holy Keys of Jerusalem
Miftāḥ al-Quds

Holy Mount (1)
Jabal al-zaytūn (1)
 (sometimes also *Ḥijāb*,

Holy Mount (2)
Jabal al-zaytūn (2)

Appendix III ❧ 115

Holy 'S'
'Alaq

Holy Salver
Kās

Holy Star of Bethlehem
Qamar Beit-laḥem

Hoopoe (1)
Hudhud (1)

116 ❦ *Appendix III*

Hoopoe (2)
Hudhud (2)

Hoopoe (3)
Hudhud (3)

Hoopoe (4)
Hudhud (4)

Jerusalem Cross
 (Crusader Cross) (1)
Ṣalīb al-Quds (1)

Appendix III ❧ 117

Jerusalem Cross (2)
Ṣalīb al-Quds (2)

Jerusalem Cross (3)
Ṣalīb al-Quds (3)

Key of Hebron
Miftaḥ al-Khalīl

Kohl Bottle (1)
Makḥaleh (1)

Kohl Bottle (2)
Makḥaleh (2)

Ladder
Sillam

Lamps *or* Lamplights (1)
Qanādīl (1)

Lamps *or* Lamplights (2)
Qanādīl (2)

Appendix III ✤ *119*

Lamps *or* Lamplights (3)
Qanādīl (3)

Lamps *or* Lamplights (4)
Qanādīl (4)

Lily (1)
Zanbaq (1)

Lily (2)
Zanbaq (2)

120 ❧ Appendix III

Lions
Usūd or *Sbū'ā*

Lovebird
Ṭayr al-ḥubb

Mihrab (prayer niche) (1)
Miḥrāb (1)

Mihrab (prayer niche) (2)
Miḥrāb (2)

Appendix III ❧ 121

Millwheel (1)
Ṭāḥūneh or *Marāweḥ* (1)

Millwheel (2)
Ṭāḥūneh or *Marāweḥ* (2)

Moon (1)
Qamar (1)

Moon (2)
Qamar (2)

122 ❧ Appendix III

Moon and Feathers (1)
Qamar b-rīsh (1)

Moon and Feathers (2)
Qamar b-rīsh (2)

Moon and Feathers (3)
Qamar b-rīsh (3)

Moon and Feathers (4)
Qamar b-rīsh (4)

Appendix III ❧ 123

Moon and Feathers (5)
Qamar b-rīsh (5)

Moon and Feathers (6)
Qamar b-rīsh (6)

Moon, foreign (St Anthony's Cross)
Qamar al-gharīb

Moon of Bethlehem (1)
Qamar Beit-laḥem (1)

124 ❧ Appendix III

Moon of Bethlehem (2)
Qamar Beit-laḥem (2)

Moon of Ramallah
Qamar Ramallah

Mulberry
Tūt

Old Man's Teeth (1)
Isnān al-ʿajūz (al-ikhtiār) (1)

Appendix III ❧ 125

Old Man's Teeth (2)
Isnān al-'ajūz (al-ikhtiār) (2)

Old Man's Teeth (3)
Isnān al-'ajūz (al-ikhtiār) (3)

Old Man's Teeth (4)
Isnān al-'ajūz (al-ikhtiār) (4)

Palm (of hand)
Kaff

126 ❧ *Appendix III*

Palm Trees (short)
Nakhl

Palm Trees (tall)
al-Nakhl al-ʿālī

Peacock (1)
Taūs (1)

Peacock (2)
Taūs (2)

Appendix III ❧ *127*

Peacock (3)
Taūs (3)

Peacock (4)
Taūs (4)

Pegtops (1)
Malāqeṭ or *Bukal* (1)

Pegtops (2)
Malāqeṭ or *Bukal* (2)

128 ❧ Appendix III

Pegtops (3)
Malāqeṭ or *Bukal* (3)

Pigeon (1)
Ḥamām or *Ṭayr* (1)

Pigeon (2)
Ḥamām or *Ṭayr* (2)

Pigeons (3)
Ḥamām or *Ṭayr* (3)

Pool *or* Harp
Birkeh

Road to Egypt (1)
Ṭarīq Maṣr (1)

Road to Egypt (2)
Ṭarīq Maṣr (2)

Road to Egypt (3)
Ṭarīq Maṣr (3)

130 ❧ *Appendix III*

Rose (1)
Ward (1)

Rose (2)
Ward (2)

Rose (3)
Ward (3)

Rose (4)
Ward (4)

Appendix III ❧ 131

Rose (5)
Ward (5)

Roundabout *or* Baker's Wife (1)
Farrāneh (1)

Roundabout *or* Baker's Wife (2)
Farrāneh (2)

Roundabout *or* Baker's Wife (3)
Farrāneh (3)

132 ❧ Appendix III

Roundabout *or* Baker's Wife (4)
Farrāneh (4)

Roundabout *or* Baker's Wife (5)
Farrāneh (5)

Saw (1)
Munshār (1)

Saw (2)
Munshār (2)

Appendix III ❧ 133

Saw (3)
Munshār (3)

Saw (4)
Munshār (4)

Saw (5)
Munshār (5)

Scorpions
'Aqāreb

134 ❧ *Appendix III*

Shepherd
Rā'ī

'Skalli' Birds (1)
Ṭuyūr (1)

'Skalli' Birds (2)
Ṭuyūr (2)

'Skalli' Birds (3)
Ṭuyūr (3)

'Skalli' Birds (4)
Ṭuyūr (4)

'Skalli' Birds (5)
Ṭuyūr (5)

'Skalli' Birds (6)
Ṭuyūr (6)

Snails (1)
Ḥalazōn (1)

136 ❧ *Appendix III*

Snails (2)
Ḥalazōn (2)

Snails (3)
Ḥalazōn (3)

Snails (4)
Ḥalazōn (4)

Snake and Serpent
al-Ḥayyeh wil-ʿarbīd

Appendix III ❧ 137

Snowflakes (1)
Nadef or *Lōzeh* (1)

Snowflakes (2)
Nadef or *Lōzeh* (2)

Snowflakes (3)
Nadef or *Lōzeh* (3)

Snowflakes (4)
Nadef or *Lōzeh* (4)

138 ❧ Appendix III

Soap
Ṣābūn

Stick (1)
ʿAṣā (1)

Stick (2)
ʿAṣā (2)

Stick (3)
ʿAṣā (3)

Appendix III ❧ 139

Sunflower *or* Garden Rose
'Ayn al-shams

Swan
Ṭayr

Syrian Inhabited Scroll (1)
'Areijeh (1)

Syrian Inhabited Scroll (2)
'Areijeh (2)

140 • Appendix III

Syrian Inhabited Scroll (3)
'Areijeh (3)

Syrian Inhabited Scroll (4)
'Areijeh (4)

Syrian Inhabited Scroll (5)
'Areijeh (5)

Syrian Inhabited Scroll (6)
'Areijeh (6)

Appendix III ❧ 141

Syrian Inhabited Scroll (7)
'Areijeh (7)

Syrian Inhabited Scroll (8)
'Areijeh (8)

Tomatoes
Bandōrā

Tree of Life
Shajrat al-ḥayāt

Wall of Jerusalem (citadel)
Sūr al-qalʿā

Watermelons
Battīkh

Notes

For full details of the works mentioned in the notes, the reader is referred to the Bibliography.

Chapter 1

1. The *Cultural Atlas of China* gives the following detailed description of the process:

 > The old Chinese methods of raising pigs, sheep, poultry, fish and silkworms had in common the creation of a controlled artificial environment for at least part of the life cycle . . . Control of the varying temperature required was a refined skill . . . Most delicate of all was the raising of silkworms. It was done in a house where warmth, humidity and light had all to be controlled, using blinds, vents and braziers. The moths had to be selected and mated. They laid their eggs on heavy sheets of paper that were stored until winter. Then the weaker eggs were killed by dipping them in brine or exposing them to the weather. When the larvae hatched they were kept in bamboo trays and fed constantly with mulberry leaves. The cocoons were spun on frames covered with straw cocks. Many of them were killed and preserved for later reelings; the rest were plunged into boiling water and reeled immediately before the new moths broke through and tore the silk. There were so many hazards, like disease, rats, a shortage of leaves, that production was surrounded by taboos and superstitions (pp. 211–212).

2. See Burt, *Weaving*. Weaving is, the author notes, a very ancient craft, and 'by 6000 BC and possibly earlier, ancient farming communities of the Near East were making cloth'. Beautiful cloth can, in fact, 'be skilfully made even with the most elementary tools and techniques' (p.1).
3. See Yusif and Khaffaji, *Ancient Egyptian Decorative Arts*, Introduction.
4. See Yusif and Khaffaji, *Ancient Egyptian Decorative Arts*, Introduction.
5. See Kiewe (ed.), *Charted Peasant Designs*, Introduction.
6. See Synge, *Antique Needlework*, ch. 1.
7. See Yusif and Khaffaji, *Ancient Egyptian Decorative Arts*, Introduction.
8. Ibid.
9. Levi (ed.), *Atlas of the Greek World*, p. 127. Greek art, the author adds, 'underwent a metamorphosis' as 'the formal but relaxed treatment of floral and whirl motifs became quite stunning in a golden cap of state found at Ak-Buran in Crimea'. The region was 'in contact with the formalized style of the art of the Steppes, with textiles of Central Asia and eventually with the Silk Road to China' (ibid.).
10. According to the *Atlas of the Greek World*, 'communication by mule-track and droving track spread like a spider's web far across the rocky surface of the earth. By the sixth century BC Chinese silks and Greek bronzes were to be found together in the tomb of a prince buried near Stuttgart' (p. 19).
11. See Synge, *Antique Needlework*, p. 1.
12. See *Atlas of the Greek World*: 'It may have been an Alexandrian', the *Atlas* adds, 'who discovered that the monsoon could take sailing ships from Aden straight across the ocean to India' (p. 186).
13. The *China Library of Nations* describes the process of early Chinese trade as follows:

 During China's golden age, industry and commerce were booming. China now welcomed foreign trade and, though it was considered demeaning, it was very profitable and contributed to the growth of a large merchant class. The trade was carried out by Chinese ships calling at ports on the Indian Ocean and by caravans of the Arabs, Indians and Persians – and a few intrepid Europeans – that made their way overland via the old Silk Road . . . Silk and porcelain were the articles coveted by the rest of the world; at the time neither was made in the West (p. 95).

14. *Cultural Atlas of China*, p. 109.
15. See Synge, *Antique Needlework*, Introduction.
16. The *Cultural Atlas of China* describes the Route thus:

 It ran west along the Gansu corridor, and through the Jade Gates Pass, beyond which – in Chinese folklore – spring was said never to go. From the Jade Gates, the two main routes ran along the north and south rims of the Tarim base, and thence over the mountains either

north into the Ferghana (now in the Soviet Union) or south into Bactria (now in Afghanistan) (pp. 14–16).

17. See *Atlas of Medieval Europe*, p. 37.
18. See Synge, *Antique Needlework*, ch. 1.
19. Ibid.
20. Embroiderers were evidently highly prized. Theodorus Prodromus, in a Greek poem of the period, says that if he followed the embroiderer's trade, his cupboard would be full of bread, wine and sardines! See ibid., p. xiii.
21. See ibid., Introduction.
22. See Messent, *Embroidery and Nature*.
23. See Synge, *Antique Needlework*.
24. See Messent, *Embroidery and Nature*.
25. See Synge, *Antique Needlework*, Introduction.
26. See Messent, *Embroidery and Nature*.
27. See Burt, *Weaving*, p. 16.

Chapter 2
1. The Macedonian also influenced Greek, Turkish, Bulgarian and Yugoslav folk art.
2. Central Asians and refugee settlers from the Balkan peninsula, in their turn, integrated their designs back into Palestinian embroidery.

Chapter 4
1. Compare the use of grey for *demi-deuil* in Europe. In fact, outside the context of mourning, blue was also sometimes considered particular to Sinai desert bedouin women living, at times, in the Negev desert. It is worth noting, however, that art and craft dealers in the Khan al-Khalili souq in Cairo label these costumes 'Egyptian bedouin', so distinguishing them from blue Palestinian village clothing with its implications of grief.

Chapter 5
1. The older practice of compulsory marriage to the male next-of-kin in the husband's family had now finally become outdated.

Conclusion
1. At the very least, a record might be kept of owners prepared to exhibit private collections in their homes on a voluntary basis.

Appendix II
1. Even very basic general terminology has, it should be noted, varied over the ages. In old records, for instance, 'embroidery' normally refers to works in silk (in contrast to the more generalized, later usage of the term, implying a two-dimensional art designed to create free-standing structures giving an impression of volume and high relief), with 'needlework' then often referring generally to decorative stitchery. In

America the term 'needlepoint' is applied to canvas work, but was earlier used for sewing lace with a needle rather than with bobbins. Metal threads were 'wrought', while wools in crewel embroidery or tent stitch were 'worked'. Berlin wool work was regarded as a form of 'needle-painting'. (See: Synge, *Antique Needlework*, p. xi; and Messent, *Embroidery and Nature*, p. 5.)

Bibliography

Non-Arabic Sources

Abercrombie, Thomas J., 'Jordan; Kingdom in the Middle', *National Geographic Magazine* (Washington, D.C.), 165:2, Feb. 1984, pp. 236–237.

Alford, Lady Marion, *Needlework as an Art*, London: Royal School of Needlework Art, 1886; reprinted London, 1975.

Allane, Lee, *Oriental Rugs: a Buyer's Guide*, London: Thames & Hudson, 1988.

Allgrove, Joan, 'Turcoman embroideries', *Embroidery* (London), XXIV:2, summer 1973.

Ambuter, Carolyn (illuss by Patti Baker Russell), *The Open Canvas*, Harmondsworth, Middx: Penguin, 1982.

Amir, Ziva, *Arabesque: Decorative Needlework from the Holy Land*, New York: Van Nostrand Reinhold, 1977.

Ancora Filati di Ricamo, *Punto a Croce*, Milan: Cucirini Cantoni, Coats, n.d.

Anson, Peter, *A Pilgrim Artist in Palestine*, London: Alexander Ousley, n.d.

Arts and Crafts of China (Russian/English/French text) (rare).

Ashley, Mike (ed.), *The Giant Book of Myths and Legends*, Bristol: Paragon, 1995.

Ashton, Leigh, *Samplers*, London/Boston: The Medici Society, 1926; reprinted London, 1970.

Atlas of Medieval Europe [Donald Matthew], Oxford: Equinox Books, c. 1983, 1989.

Baldensperger, Philip, *The Immovable East*, London, 1913.

Ball, C.J., *Light from the East; or the Witness of the Monuments: an Introduction to the Study of Biblical Archaeology*, London, 1899.

Ball, Katherine M., *Decorative Motives of Oriental Art*, New York: Paragon, 1927 (very rare).

Banateanu, Fosca, and Banateanu, Ionescu, *Folk Costumes of Roumania*, Bucharest, 1958.

Baramki, Dimitri C., *The Art and Architecture of Ancient Palestine: a Survey of the Archaeology of Palestine from the Earliest Time to the Ottoman Conquest*, Beirut: PLO Research Centre, 1969.

Bauer, Leonhard, 'Kleidung und Schmuck der Araber Palästinas', *Zeitschrift des Deutschen-Palästina-Vereins* (Leipzig), XXIV, 1901.

Beany, Jan, *Stitches: New Approaches*, London: Batsford, 1985.

Beck, Thomasina, *Embroidered Gardens* (Studio Book Series), New York: Viking Press, 1979.

Benaki Museum, *Coptic Textiles*, Athens, 1971.

—— *Epirus and Ionian Islands Embroideries*, Athens, 1965.

—— *Islamic Textiles*, Athens, 1974.

—— *Skyros Embroideries*, Athens, 1965.

Berry, B.Y., 'Turkish Embroidery', *Embroidery* (London), IV:3, June 1936.

Besbas, F., 'Le tissage de la soie à Tunis', in Revault, *Arts traditionnels en Tunisie*, pp. 401–402.

Bhavnani, Enakshi, *Decorative Designs and Craftsmanship of India*, New York: Paragon, 1969.

Binyon, L., *Chinese Art: an Introductory Handbook to Painting, Sculpture, Ceramics, Textiles, Bronzes and Minor Arts*, 6th edn, 1958.

Bird, Junius (with technical analysis by Louisa Bellinger), *Paracus Fabrics and Nazca Needlework*, Philadelphia: National Publishing Co., 1954.

Birdwood, G.C.M., *The Industrial Arts of India*, new edn, London, 1884.

Birrell, Verla, *The Textile Arts: a Handbook of Fabric Structure and Design*, New York: Harper, 1959.

Boger, Louise, and Batterson H. (eds.), *The Dictionary of Antiques and the Decorative Arts*, enlarged edn, New York: Scribner, 1957, 1967.

Boisselier, Jean, *Tendances de l'art Khmer: commentaire sur 24 chef-*

d'œuvres du Musée de Phnom Penh, Paris: Publication du Musée Guimet, 1956.

Boler, James, *The Needle's Excellency* (pattern book), London, 1631.

Bossert, H.T., *Ornamente der Volkskunst*, Tübingen, 1949.

Bowie, Theodore, et al., *East-West in Art: Patterns of Cultural and Aesthetic Relationships*, New York: Paragon, 1966.

Bridgeman, Harriet, and Drury, Elizabeth, *Needlework: an Illustrated History*, London, 1978.

British Museum, *British Museum Guide*, London, 1976.

—— *Village Arts of Romania*, London, 1971.

Buckingham, J.S., *Travels among the Arab tribes Inhabiting the Countries East of Syria and Palestine, Including a Journey from Nazareth to the Mountains*, London: Longman, Hurst and others, 1824.

—— *Travels in Palestine, through the Countries of Bashan and Gilead, East of the River Jordan*, London: Longman, 1821.

Burckhard, J.L., *Travels in Syria and the Holy Land*, London, 1822.

Burt, Ben, *Weaving: Discovering Other Cultures* (Museum of Mankind, London), London: British Museum Publications, 1977, reprinted 1981.

Cammaan, Nora, *Needlepoint Designs from American Indian Arts*, New York: Scribner, 1973.

Cammaan, Schuyler, *China's Dragon Robes*, New York: Ronald Press, 1952.

—— 'Embroidery Techniques in Old China', *Archives of the Chinese Art Society of America*, XVI, 1962.

Casson, Lionel, *The Pharaohs* (Treasures of the World Series), New York: Select Books, 1982.

Caufield, S.F.A., and Saward, C., *The Dictionary of Needlework*, London: L. Upcott Gill, 1882, 1903.

Chadirji, Rifat, *The Photography of Kamil Chadirji: Social Life in the Middle East, 1920–1940*, Surbiton, Surrey: Laam, 1991.

Chambers, William, *Designs of Chinese Buildings, Furniture, Dresses, Machines and Utensils; from Originals Drawn in China*, 1757 edn, reprinted London, 1969.

China (Library of Nations Series) (ed. by Martin Mann), Amsterdam: Time-Life Books, 1989.

Chinese Art: Symbols and Images (intro. by Max Loehr), Mayling Soong Foundation and Wellsley College, 1967.

Christie, A.G.I., *Samplers and Stitches*, London, 1921.

Ciba Review, 'Medieval Dyeing', Basle, 1937.

Clark, Leslie J., *The Craftsman in Textiles*, G. Bell & Sons, 1968.

Clermont-Gannaeau, C., 'Sur quelques noms de vêtements chez les Arabes de Palestine', *Recueil d'Archéologie Orientale* (Paris), IV, 1909, pp. 264–265.

Coke, Richard, *The Arab's Place in the Sun*, London: Butterworth, 1929.

Collinet, Julien, *Arachne, ou l'art de la tapisserie*, Geneva: Ed. de la Coulouvrenière, 1971.

Commonwealth Institute Exhibition: Artists, Craftsmen of 401.5 and Fossway House Workshops, 1970–1980, London, 1979.

Coney, J.D., *Late Egyptian and Coptic Art*, Brooklyn, N.Y.: Brooklyn Museum, 1943.

Corbin, Henry, et al., *L'art de l'Iran l'ancienne Perse et Bagdad*, Paris, 1938.

Country Bazaar (New York) (McCall's Creative Crafts Series), 12:4, 1984.

Country Handcrafts, Milwaukee: Reiman Publications, 9:5/6, 1991; 10:1–4, 1991–92.

Crafts Magazine, Peoria, Ill.: P.J.S. Publications, 8:10, 1985.

Creswell, K.A.C., *A Bibliography of the Architecture, Arts and Crafts of Islam* (1st edn, Jan. 1960), Cairo: American University of Cairo, 1961.

Creten, J. (trans. from German by Colville and Gladys Wheelhouse), *The Holy Land*, Munich: W. Andermann Verlag, 1958.

Crowfoot, Grace M., 'Bethlehem Embroidery', *Embroidery* (London), V:1, Dec. 1936.

—— and Sutton, Phyllis M., 'Ramallah Embroidery: Introduction to the Study of Palestinian Embroidery', *Embroidery* (London), III:2, March 1935.

Crowley, Robert, *The Rulers of Britain* (Treasures of the World Series), New York: Select Books, 1982.

Cultural Atlas of China [Caroline Blunden and Mark Elvin] (Time-Life Book Series), Oxford: Equinox Books, *c.* 1983, 1988.

Cumming, Elizabeth, and Kaplan, Wendy, *The Arts and Crafts Movement*, London: Thames & Hudson, *c.* 1991, reprinted 1995.

Dalman, Gustav, *Arbeit und Sitte in Palästina*, Hildesheim: Georg Olms, 1930, reprinted 1964, 1972.

D'Alviella, Count Goblet, *The Migration of Symbols*, New York: University Books, 1965.

Daoud, Azize, 'Ramallah Embroidery and Ramallah Weaving', Jerusalem, Palestine Government Schools, 1930 (unpublished ms).

Davis, Hugh William (compiler), *Bernhard von Breydenbach and his Journey to the Holy Land, 1483–1484: a bibliography*, Utrecht:

Haentjens, Dekker & Gumbert, 1968 (reprint of London: Leighton, 1911).
Day, Lewis F., *Art in Needlework*, London: Batsford, 1967.
Delivorrias, A., *A Guide to the Benaki Museum*, Athens: Benaki Museum Publications, 1980.
D'Harcourt, Raoul, et al., *Textiles of Ancient Peru and Their Techniques*, Washington, D.C.: University of Washington Press, 1962.
Dickey, Thomas, et. al., *The God-Kings of Mexico* (Treasures of the World Series), Amsterdam: Select Books, 1983.
Dictionary of the Decorative Arts (comp. by John Fleming and Hugh Honour), New York: Harper & Row, 1977.
Dictionnaire illustré des antiquités et de la brocante (*dirigeur* Jean Bedel), Paris: Larousse, 1984.
Digby, George Wingfield, 'Chinese Court and Dragon Robes', *Connoisseur*, CXXVI, 1950.
de Dillmont, Thérèse, *Encyclopaedia of Needlework*, Mulhouse: D.M.C. Library (reprint of 1980 edn).
Dixon, Margaret, *The Wool Book*, London: Hamlyn, 1979.
D.M.C., *Broderies au point de croix*, Mulhouse: Bibliothèque D.M.C., 1976.
—— *Exesia Kevlnuatwr Me D.M.C.* (Greek text), Mulhouse: D.M.C. Publications, n.d.
—— *Point de croix*, Mulhouse: Bibliothèque D.M.C., n.d.
—— *Turkish Embroideries*, Mulhouse: Bibliothèque D.M.C., n.d.
Elliot, Inger McCabe, *Batik: Fabled Cloth of Java*, New York: Clarkson N. Potter, 1984.
Embroidery Transfers (des. Takiko Moriyama): Variety in Cushion Design, Tokyo: Kamaturu Shobo, Series no. 10, n.d.
Encyclopaedia of Embroidery, London: Marshall Cavendish, 1972–84.
The Englishwoman's Domestic Magazine (nineteenth-century periodical).
Epstein, Roslyn, *American Indian Needlepoint Designs*, New York: Dover, 1981.
Ewald, Mrs, *Jerusalem and the Holy Land: Being a Collection of Lithographic Views and Native Costumes from Drawings Taken on the Spot*, London, 1854.
Farbridge, Maurice H., *Studies in Biblical and Semitic Symbolism*, London, 1923.
Fél, Edit (trans. by Annie Barát and Lily Hálápy), *Hungarian Peasant Embroidery*, London: Batsford, 1961.
Ferguson, J.C., *Survey of Chinese Art: Notes on Bronze Stone Monuments, Calligraphy, Painting, Jades, Ceramics, Architecture,*

Furniture, Textiles and Miscellaneous Arts, Shanghai, 1940.

Fernald, Helen E., *Chinese Court Costumes*, Toronto: University of Toronto Press, 1964.

Ferrero, Mercedes Viale, *Tapis d'orient et d'occident*, Paris: Grange Batelière, 1970.

Fisher, Joan, *The Creative Art of Needlepoint Tapestry*, London: Hamlyn, 1972.

Ford, P.R.J., *Oriental Carpet Design: a Guide to Traditional Motifs and Symbols*, London: Thames & Hudson, pb edn, 1992.

Foris, Maria (ed. by Andreas Foris, intro. by Heinz Edgar Kiewe), *Charted Folk Designs for Cross-stitch Embroidery: 278 Charts of Ancient Folk Embroideries from the Countries Along the Danube*, New York: Dover, 1975. (First pub. Nuremberg: Sebaldus Verlag, 1950.)

Gadsby, John, *My Wanderings: Being Travels in the East, 1846–47, 1850–51, 1852–53*, rev. edn, London, 1876.

Geutles, Margaret, *Turkish and Greek Island Embroideries*, Chicago: Art Institute of Chicago, 1964.

Gibbs-Smith, Charles, *The Bayeux Tapestry: a Comprehensive Survey*, 2nd edn, London Museums' Association, 1971.

Gierl, Irmgard, *Cross-stitch Patterns*, London: Batsford, 1982.

Girls' Own Annual (nineteenth-century English periodical).

Golvin, L., 'Les tissages de El-Djem et Djebaniana', in Revault, *Arts traditionnels en Tunisie*, Tunis: IBLA, 1949.

Golvin, L.S. and Louis, 'Artisans sfaxiens', in Revault, *Arts traditionnels en Tunisie*, Tunis: IBLA, 1946, no. 7.

Good Housekeeping Embroidery (chief contributor, Dorothea Hall), London: Ebury Press, 1981.

Goodrich-Freer, A., *Arabs in Tent and Town*, London, 1924.

Gostelow, Mary, *Art of Embroidery: Great Needlework Collections of Britain and the United States*, London, 1979.

—— *Embroidery: Traditional Designs, Techniques and Patterns*, London: Cavendish House, 1977.

—— *A World of Embroidery*, London/New York: Mills & Boon/Scribner, 1975.

Graham, Stephen, *With the Russian Pilgrims to Jerusalem*, London: MacMillan, 1914.

Graham-Brown, Sarah, *Palestinians and Their Society, 1880–1946*, London: Quartet, 1980.

Granqvist, Hilma, *Birth and Childhood Among the Arabs*, Helsinki: Soderstron, 1947.

—— *Marriage Conditions in a Palestinian Village*, Helsinki: Soderstron, 1931.

Grant, Elihu, *The People of Palestine*, Philadelphia, 1921.

Groves, Sylvia, *The History of Needlework Tools and Accessories*, London: Country Life, 1966.

Hackenbroch, Yvonne, *English and Other Needlework Tapestries and Textiles in the Irwin/Untermeyer Collection*, Cambridge, Mass.: Harvard University Press, 1960.

Hahn, Hissink Karin, *Volkskunst aus Guatemala*, Frankfurt: Museum für Volkerkunde, 1971.

Hallade, Madeleine, *Arts de l'Asie ancienne: thèmes et motifs*, Vol. III: *La Chine*, Paris: Publication du Musée Guimet, 1956.

Halpenn, Frieda, *Full color Russian Folk Needlepoint Designed; Charted for Easy Use*, New York: Dover, 1974.

Harden, Donald, *The Phoenicians*, London: Thames & Hudson, 1962.

Hibbert, Christopher, *The Emperors of China* (Treasures of the World Series), New York: Select Books, 1982.

Historical Atlas, Maplewood, N.J.: Hammond, 1972.

Howells, Victor, *A Naturalist in Palestine*, London: Andrew Melrose, 1956.

Huish, Marcus B., *Samplers and Tapestry Embroideries*, London: Longmans Green, 1900.

Husseini, Zeinab Jawad, *Palestinian Arab Folklore Centre* (English/Arabic text), Jerusalem: al-Shark Arab Press, 1981.

Hyde, Nina, 'The Queen of Textiles', *National Geographic Magazine* (Washington, D.C.), 165:1, Jan. 1984, pp. 2–49.

Iles, Jane, de Leon, Suzie, and Skelton, Valerie, *Machine Embroidery*, London: Studio Vista/Cassell, 1979.

Iranie, Hannie J., and Hannush, N., 'Palestinian Embroideries', Jerusalem, 1920 (unpublished ms).

Irwin, John, and Hall, Margaret, *Indian Embroideries*, India: S.R. Bastiker, 1973.

Jacques, Renate, *Mittelalterlicher Textildruck am Rhein*, Kevalaer, 1930.

Jamali, Sara Powell (illuss by Jeanne Shelsher), *Folktales from the City of Golden Domes*, Beirut: Khayat, 1965.

Japan, Soshoin Office, *Textiles in the Soshoin*, Tokyo, 1963–64 (extremely rare).

Jessen, Ellen, *Ancient Peruvian Textile Design in Modern Stitchery*, New York: Van Nostrand Reinhold, 1972.

—— *Peruvian Designs for Cross-stitch*, New York: Van Nostrand Reinhold, 1980.

de Jode, Gerard, *Thesaurus sacrarum historiarum veteris testamenti* (pattern book), Antwerp, 1585.

Johnstone, Pauline, *Greek Island Embroidery*, London, 1961.

—— *A Guide to Greek Island Embroidery*, London: HMSO, 1972.

—— 'Persian Dress and Western Embroidery', *Embroidery* (London), X:4, winter 1959.

Jones, Christina, *The Ramallah Handicraft Cooperative*, Ramallah, 1962.

Jordan Museum of Popular Traditions (intro. by Sadiyeh Wasfi Tel), Amman: Jordan Press Foundation, n.d.

Jouin, Jeanne, 'Le costume féminin dans l'Islam Syro-Palestinien', *Revue des Etudes Islamiques* (Paris), 1934, pp. 481–501.

Judge, Joseph, 'This Year in Jerusalem', *National Geographic Magazine* (Washington, D.C.), 163:4, April 1983, pp. 479–515.

Kaestner, Dorothy, *Four Way Bargello*, London: Bell & Hyman, 1984.

—— *Needlepoint Bargello*, London: Bell & Hyman, 1984.

Kerimov, Lyatif, *Persian Rug Motifs for Needlepoint, Charted for Easy Use*, selection from vol. 1 of *The Azerbaijani Carpet* (Russian text), Baku-Leningrad/New York: Azerbaijani Academy of Sciences/Dover, 1975.

Kiernan, Thomas, *The Arabs: Their History, Aims and Challenge to the Industrial World*, London: Abacus, 1975–78.

Kiewe, Heinz Edgar, *Ancient Berber Tapestries and Rugs*, Oxford, 1952.

—— (ed.), *Charted Peasant Designs from Saxon Transylvania*, New York: Dover, 1977.

—— *History of Folk Cross-stitch*, Nuremberg, 1962.

—— 'Muslim Embroideries', in *Traditional Embroideries from the Holy Land and Norway*, Oxford, 1954.

Kinmond, Jean, *The Coats Book of Modern European Embroidery*, London: Batsford, 1979.

Klein, F.A., 'Mitteilungen über Leben, Sitten und Gebräuche der Fellachen in Palästina', *Zeitschrift des Deutschen-Palästina-Vereins* (Leipzig), IV, 1881.

Kolbenheyer, Erich, *Motive der hausindustriellen Slickerei in der Bukowina*, Czernowitz, 1912.

Kondert, Johann, *Geschichte die Siebenburger Sachsen*, Munich, 1955.

Koniezny, M., *Textiles of Baluchistan*, London: British Museum Publications, 1979.

Kreuger, Glee F., *A Gallery of American Samplers*, New York, 1980.

The Ladies' Treasury (nineteenth-century English periodical).

Lampton (ed. by Susan Sedlacek), *Needlepoint Techniques and*

Projects, Menlo Park, Calif.: Lane Books, 1972.

Landau, Rom, *Arab Contribution to Civilisation*, California: American Academy of Asian Studies, 1958.

Lawrence, Martin (compiler), *The Compleat Craftsman: Yesterday's Handicraft Projects for Today's Family*, London: Murray, 1978.

Lees, G. Robinson, *Village Life in Palestine: a Description of the Religion, Home Life, Manners, Customs, Characteristics and Superstitions of the Peasants of Palestine*, London: Longmans Green, 1905.

Atlas of the Greek world [Peter Levi] (Equinox Books), Oxford: Phaidon Press, c. 1984, 1989.

Lindberg, Jana Hauschild, *Counted Cross-stitch Designs for all Seasons*, London: Bell & Hyman, 1984.

Lipman, Jean, *Techniques in American Folk Decoration*, New York: Dover, 1951.

Liverpool Public Museums, *Catalogue of Mediterranean Embroideries*, Liverpool, 1956.

Lubell, Cecil (ed.), *Textile Collections of the World*, London: Studio Vista, 1976.

Lutfiyya, A.M., *Baytin, a Jordanian Village: a Study of Social Institutions and Social Change in a Folk Community*, London: Mouton, 1966.

Macdonald, Angus, *Historic Scenes in Egypt and Palestine, with Sketches of Places, People and Their Customs*, London: Marshall Bros., 1921.

MacDonald, Jan, 'Palestinian Dress', *Palestine Exploration Fund Quarterly* (London), XI–XVII, 1951, pp. 55–68.

Maclagan, Eric, *The Bayeux Tapestry*, London/New York, 1943, 1949.

Macmillan, Susan L., *Greek Island Embroideries*, Boston, Mass.: Museum of Fine Arts, 1973.

Macmillan Encyclopedia of Art (ed. by Bernard L. Meyers and Trewin Copplestone), London: Macmillan, rev. edn, 1979.

Mani di Fata Series, *Punti a giorni*, Milan: Mani di Fata, 1974.

—— *Il punto ombra*, Milan: Mani di Fata, 1977.

—— *Ricami d'Assisi*, Milan: Mani di Fata, n.d.

Manning, Samuel, *Those Holy Fields: Palestine Illustrated by Pen and Pencil*, London: Religious Tract Society, 1874.

May, Florence Lewis, *Silk Textiles of Spain*, New York, 1957.

Mayorcas, M.J., *English Needlework Carpets*, Leigh-on-Sea, 1963.

McCall's Needle Art Series: Cross-stitch, by eds. of *McCall's Needlework and Crafts*, New York: McCall Pattern Co., 1965.

Messent, Jan, *Embroidery and Animals*, London: Batsford, 1984.

—— *Embroidery and Architecture*, London: Batsford, 1985.
—— *Embroidery and Nature*, London: Batsford, 1980.
Meulenbelt-Nieuwburg, Albarta (trans. from Dutch by Patricia Wardle and Gillian Downing), *Embroidery Motifs from Dutch Samplers*, Amsterdam/London, H.J. Bechts Vitgeversmaatschappij/Batsford, 1974.
Milburn, A.R.L., *Saints and Their Emblems*, Oxford, 1957.
Miller, William, *The Latins in the Levant*, New York: Barnes & Noble, 1964.
Modes et travaux, Paris, no. 1,000, March 1984.
Morrall, M.T., *A history of Needlework*, 1852.
Musée des Arts et Traditions Populaires de Tunis (et de Sfax): see Revault, *Arts traditionnels en Tunisie*.
Musée de Bardo: see Revault, *Arts traditionnels en Tunisie*.
Museum of Costume, Bath, Avon; Assembly Rooms Exhibition.
Museum of London, London Wall Exhibition.
Museum für Volkerkunde, *Brasiliens Indianer*, Vienna, n.d.
—— *Indianer in Südamerika*, Vienna, 1973.
N/Dar, S., *Costumes of India and Pakistan: a Historical and Cultural Study*, New York: Paragon, 1969.
Namikawa, Banri (photographer), *Costumes Dyed in the Sun, Palestinian Arab National Costumes* (Japanese/English text) (Widad Kamel Qawar Collection), Tokyo: Bunka Publishing Bureau, 1982.
National Palace Museum (Beijing), *Chinese Cultural Art Treasures* (Chinese text), 4th edn, 1967, pp. 130–134.
Ness, Pamela Miller, *Assisi Embroidery: Technique and 42 Charted Designs*, New York: Dover, 1979.
—— *Norwegian Smyrna Cross-stitch: Technique and 39 Charted Designs*, New York: Dover, 1982.
—— *Swedish Tvistom Embroidery: Technique and 46 Charted Designs*, New York: Dover, 1981.
Nichols, Marion, *Encyclopaedia of Embroidery Stitches; Icrewel*, New York: Dover, 1974.
Niel, C. Lang (comp. and ed.), *Pictorial Palestine: Ancient and Modern*, London, Miles & Miles, n.d.
Nottingham Museum of Costume, Exhibition.
Oprescu, George, *Peasant Art in Roumania*, London, 1929.
Ostaus, Giovanni, *La vera perfezione del disegno per punti e ricami*, Bergamo, 1909.
Owen, Mrs Henry, *The Illuminated Book of Needlework*, 1847.
Oz, Tahsin, *Turkish Textiles and Velvets*, Ankara, 1950.

Papantoniou, Ioanna, *Greek Costumes*, Athens, Peloponnesian Folklore Foundation, 1981.
Persuy, Annie, and Evrard, Sun, *La reliure*, Paris: Denoel, 1984.
Pesel, L.F.S.A., and Newberry, E.W., *Book of Old Embroidery*, 1921.
Pesel, Louisa F., *Stitches from Eastern Embroideries*, London: Batsford, 1916, portfolio no. 2.
Petrakis, Joan, *The Needle Arts of Greece: Design and Technique*, New York: Scribner, 1977.
Phillpott, Pat, *The Craft of Embroidery*, London: Stanley Paul, 1976.
Picton, John, and Mack, John, *African Textiles: Looms, Weaving and Design*, London: British Museum Publications, 1979.
Pierotti, Ermete, *Costumes de la Palestine, avec explication*, Paris: chez l'auteur, 1871.
Pisti, Mara Hidri, *A Collection of Folk Motifs from Macedonia, Kosova and Metodria*, Belgrade: Socialist Republic of Serbia Publishing House, n.d.
Popodopoulous, S.A. (ed.), *Greek Handicrafts*, Athens: National Bank of Greece, 1969.
Popstefanieva, Maritza Antonova (ed.), *Broderies nationales macédoniennes, destinées à l'application pratique* (Yugoslav/French text), Belgrade: Institut de la Folklore de la République Populaire de Macédonie, Section de l'Art Textile National, n.d.
Proctor, Molly G., *Victorian Canvas Work: Berlin Wool Work*, London: Batsford, 1972.
Pyman, Kit, *Needlecraft Series 1–16*, London: Search Press, 1978.
Ramazanoglu, Gulseren, *Turkish Embroidery*, New York: Van Nostrand Reinhold, 1976.
Rand-McNally, *Historical Atlas of the World*, Chicago, 1961.
Rawlinson, George, *History of Phoenicia*, London, 1889.
Reader's Digest, *Complete Guide to Needlework*, London, 1981.
Revault, Jacques, *Arts traditionnels en Tunisie*, Tunis: Office National de l'Artisanat de Tunisie, 1967.
—— 'Broderies tunisiennes', *Cahier de Tunisie* (Tunis), 1960, n. 29–30.
—— and Poinssot, L., 'Tapis tunisiens', in *Arts traditionnels et Tunisie*, vols I–IV, Paris, 1937, 1950, 1953, 1957.
Rhodes, Mary, *Ideas for Canvas Work*, London: Batsford, 1984.
Ribaric, Jelka Radaus (with technical description by Blazena Sgenczi *Folk Embroidery from Hravatske [Yugoslavia]*, Hravatske: Grafic Zavod, 1976.
—— *Yugoslavian/Croatian Folk Embroidery*, New York: V Nostrand Reinhold, 1976.

Ricard, P., 'Pour comprendre l'art musulman dans l'Afrique du Nord et en Espagne', in Revault, *Arts traditionnels en Tunisie.*

Rice, Tamara Talbot, *Ancient Arts of Central Asia*, New York: Paragon, 1965.

Ring, Betty (ed.), *Needlework: an Historical Survey*, New York, 1975.

Risley, Christine, *Creative Embroidery*, London: Studio Vista, 1969.

Roger-Vercel, Simone, *Savoir faire les ouvrages de dames*, Paris: Gautier-Languereau, 1968.

Rogers, Gay Ann, *Needlepoint Design from Asia*, London: Robert Hale, 1984.

Rosenstand, Eva, and Waever, Clara, *1984/85 Catalogue* (Rochester, Kent).

Rothemund, B., *Byzantinische und russische Stickereien*, Munich, 1961.

Rothstein, Gustav, 'Moslemische Hochzeitsgebräuche in Lifta bei Jerusalem', *Palästina-Jahrbuch* (Berlin), VI, 1910.

Rottenbacher, Elfriede, *Alpenländische Handarbeitsmuster*, Graz, 1956.

Ruedin, E. Gans, *Tapis d'orient* (Orbis pictus: 14), Berne, Payot, Lausanne, 1955.

Schuette, Marie, and Muller-Christensen, Sigrid, *The Art of Embroidery*, London: Thames & Hudson, 1964.

Seaton, Robert, *A Companion to Seaton's Map of Palestine and Egypt*, London: James Neele, 1837.

Sebba, Anne, *Samplers: Five Centuries of Gentle Craft*, London, 1979.

Shorleyker, Richard, *A Schole House for the Needle* (pattern book), London, 1624.

Shouker, Kay, *Fodor's Jordan and the Holy Land*, rev. edn, New York: Fodor's Travel Guides, 1984.

Sibmacher, Johan, *Baroque Charted Designs for Needlework* (engraved), New York: Dover, 1981 (first pub. in 1604).

Siegler, Susan, *Needlework Patterns from the Metropolitan Museum of Art*, Boston: New York Graphic Society, 1976.

Smithsonian Institution, *Official Guide*, Washington, D.C.: C.B.S. Publications, 1973.

Snook, Barbara, *English Embroidery*, London: Batsford, 1970.

Spoer, H.H., 'Volkskundliches aus el Qubebe bei Jerusalem', *Zeitschrift für Semitik und Verwandte Gebiete* (Leipzig), VI, 1927.

Springall, Diana (ed. by Jenny Rogers), *Embroidery*, London: BBC, 1980, 1981.

Staatliches Museum für Volkerkunde, *Altamerikanische Kunst Mexico-Peru*, Munich, 1968.

Start, Laura E., 'Embroideries Old and New, xv and xvi: Russian Peasant Embroideries', *The Needlewoman* (London), 15, 1922; 16, 1932.
Stent, Peter, *A book of Flowers, Fruits, Beasts, Birds and Flies* (pattern book), 1650.
Stenton, Frank (ed.), *The Bayeux Tapestry: a Comprehensive Survey*, 2nd edn, London, 1965.
Sullivan, Michael, *The Arts of China*, Berkeley: University of California Press, 1967.
Sunset Books, *Needlepoint*, Menlow Park, Calif.: Lane Books, 1972.
—— *Stitchery: Embroidery, Appliqué, Crewel*, Menlow Park, Calif.: Lane Books, 1974.
Svinicki, Eunice, *Spinning and Dyeing*, New York: Golden Press, 1974.
Swain, Margaret H., *Historical Needlework: a Study of Influences in Scotland and Northern England*, Barrie & Jenkins, 1970.
Symonds, Mary, and Preece, Louisa, *Needlework in Religion*, London, 1923.
—— *Needlework Through the Ages,* London: Hodder & Stoughton, 1928.
Synge, Lanto, *Antique Needlework*, Poole, Dorset: Blanford Press, 1982.
Szechuan, Kung-I Mei-She Hsuan Chi (ed. by Ch'eng Poi-wen and others), *Handicraft in Szechuan Province* (Chinese text), Cheng-tu, 1959.
Thompson, Stith, *Motif Index of Folk Literature*, rev. edn, Bloomingdale, Ind., 1955.
Thorne-Thomsen, Kathleen, and Burns, Hildy Page, *American Cross-stitch*, New York: Van Nostrand Reinhold, 1980.
Tidball, Harriet, *Contemporary Tapestry*, Big Sur, Calif.: Shuttlecraft Guild, 1964.
Trésors des musées du Kremlin, Catalogue of exhibition, Paris, 1979.
Tricot decoration (Paris, quarterly), 1977.
Tunis: Office National de l'Artisanat Tunisien, *Catalogue tapis*, Tunis.
Turner, Diana Oliver, *African Needlepoint Designs, Charted for Easy Use*, New York: Dover, 1976.
Ugbroke House (Chudleigh, Devon), Exhibition of Seventeenth- and Eighteenth-Century Embroideries and Tapestries.
Ulmer, Friedrich, 'Arabische Stickmuster', *Zeitschrift des Deutschen-Palästina-Vereins* (Leipzig), XLIV, 1921.
Uradi, Sama (Belgrade periodical), Nov. 1983.
Vaclavik, Antonin, and Orel, Jaroslav, *Textile Folk Art*, London: Spring Books, n.d.
Vavassore, Giovanni Andrea, *Esemplario di Lavori*, Bergamo, 1910.

Victoria & Albert Museum, *English Embroideries* (Picture Books Series), London, 1928.

Vinciolo, Frederico, *I singolar e nuovi disegni*, Bergamo, 1809.

Volbach, W.F., *Catalogo del Museo Sacro*, vol. III, Vatican City, 1942.

—— *Early Christian Art*, London, 1961.

Von Palotay, G., 'Turkish Embroideries', *CIBA Review* (Basle), 102, 1954.

Wace, A.J.B., *Mediterranean Embroideries*, Liverpool Public Museum, 1956.

—— *Mediterranean and Near Eastern Embroideries*, London: Halfont Co., 1935.

—— 'Persian embroidery', *The Embroiderers* (London), 1931.

Wardle, Patricia, *Guide to English Embroidery*, London: Victoria & Albert Museum, 1970.

Wassif, Forman-Wissa, *Tapestries from Egypt*, London: Hamlyn, 1961.

Weir, Shelagh, *Palestinian Costume*, London: British Museum Publications, 1989.

—— *Palestinian Embroidery: Village Arab Craft*, London: British Museum Trustees, 1970.

—— 'The Traditional Costumes of the Arab Women of Palestine', *Costume* (London), III, 1969.

—— and Shahid, Serene, *Palestinian Embroidery: Cross-stitch Patterns from the Traditional Costumes of the Village Women of Palestine*, London: British Museum Publications, 1988.

Weiss, Rita (ed.), *Victorian Needlepoint: Designs from Godey's Lady Book and Peterson's Magazine*, New York: Dover, 1975.

Whymant, Neville, 'Traditional Chinese Embroidery', *Embroidery* (London), III:4, Sept. 1935.

Whyte, Kathleen, *Design in Embroidery*, London: Batsford, 1969.

Wiebel, Adele Coulin, *Two Thousand Years of Textiles*, New York: Pantheon, 1952.

Williams, C.A.S., *Outlines of Chinese Symbolism*, Peiping Custom College Press, 1931.

Wilson, C.T., *Peasant Life in the Holy Land*, London, 1906.

Wilson, Erica, *Erica Wilson's Embroidery Book*, New York: Scribner, 1973; London: Faber, 1975.

Witts, Susan, *Classics for Needlepoint*, Birmingham, Ala.: Oxmoor House, 1981.

Woman's Day, 'Needlecraft and Handicraft Ideas', Greenwich, Conn.: Fawcett Publications, 1977:24.

Women's Institute Book of Country Crafts: a Collection of Traditional Skills, London: Chancellor Press, *c*. 1994.

Wulff, Hans, *Traditional Crafts of Persia*, Leipzig, 1939; reprinted Cambridge, Mass.: M.I.T. Press, 1966.
The Young Ladies' Journal (nineteenth-century English periodical), London, 1872.
Zananiri, Josephine, 'Embroidery Flourishes After Phase of Reformation', interview with Leila El Khalidi, *Jordan Times: Home News*, 21 June 1986, p. 3.
Zaru, Samia, *Tents and Stones* (exhibition), Palestine Week, United Nations, New York, 1989.
Zervos, Christian, *L'art en Grèce*, London, 1934.
Ziemba, William T., et al., *Turkish Flat Weaves: an Introduction to the Weaving and Culture of Anatolia*, Vancouver: Yoruk Carpets and Kilims, 1979.
Znamierowski, Nell, *Step-by-Step Weaving: a Complete Introduction to the Craft of Weaving*, New York: Golden Press, 1967.
—— (ed. by William and Shirley Sayles), *Step-by-Step Rugmaking: a Complete Introduction to the Craft of Rugmaking*, New York/Racine, Wisc., Golden Press/Western Publishing Co., 1972.
Zora, Popi, *Greek Folk Art* (text), Athens: Lucy Braggiotti, 1980.

Arabic Sources (titles translated into English)

Abbud, Elias, 'Al-Qlei'a and Deir Mimas; Properties of Economic and Social Change from Palestine to the Israeli Occupation', *Samed al-Iqtisadi* (Beirut), 3:19, Aug. 1980, pp. 121–132. (Includes artisanship, textiles, weaving.)
'Abd al-Hadi, Tawaddud, *Folk Tales*, Beirut: Dar Ibn Rushd, 1980.
'Abd al-Jabir, Taysir, *Technical and Economic Feasibility Study*, Amman: Tourist Industries, Training and Production Centre, n.d. (ms in Abu 'Ali, 'Artisan Heritage Industries').
'Abdallah, Ibn al-Muqaffa', *Kalila and Dimna*, new rev. and enlarged edn, ed. by 'Abd al-Wahhab Azzam, intro. by Ahmad Talib al-Ibrahimi, Beirut/Algiers: Dar al-Shuruq/Algerian National Distribution Co., 1973.
'Abdallah, Nizar, 'Industrial-Sector Conditions in the West Bank and Gaza Strip', *Samed al-Iqtisadi* (Beirut), 2:11, Dec. 1979, pp. 5–14.
Abu 'Ali, Muyassar, 'Artisan Heritage Industries in Palestine', *Samed al-Iqtisadi* (Amman), 9:67–68, pp. 138–150. (Includes costumes.)
Abu 'Umar, 'Abd al-Sami', *Traditional Palestinian Embroidery and Jewellery*, Jerusalem: Eastern Arab Press, 1986. (Includes English text.)

Ali, Thurayya, *The Bride: Costume and Cosmetics in Folk Arts*, Cairo: Madbuli Book Publishers, 1988 (date of intro.).
Arab Women's Union, *Bethlehem Folklore Museum*, Jerusalem: Franciscan Fathers' Press, 1985.
'Arnita, Yusra Jawhariyyeh, *Folk Arts in Palestine* (Palestine Books Series, 14), Beirut: PLO Research Centre, 1968.
al-Ashhab, Rushdi, 'Legends/Fables and Folk Preferences', *Literary Dawn*, 8:21, Apr. 1981, p. 4.
Badran, Nabil, 'Production Institutions for the Palestinian Revolution', *Samed al-Iqtisadi* (Beirut), 2:12, Jan. 1980, pp. 23–40.
—— 'Samed: a Palestinian Socio-economic Experiment', *Samed al-Iqtisadi* (Beirut), 1:11/12, Dec. 1978, pp. 100–108.
Bakj, Arslan Ramadan, *Jordanian Palestinian Illustrated Heritage*, Amman, 1981. (Explanatory notes in Arabic, English and French.)
Bauer, D. Leonhardt (trans. from German by Khaled Sirhan), *Costume and Jewellery of the Palestinian Arabs*, Amman: PLO Dept of Information and Culture, 1985.
Birmoff, Nuri (trans. from Russian by Muhammad Tayyar), *Turkmania in Colour* (World's Seven Colours; Turkman Papers Series), Moscow: Radoga House, 1987. (Deals with silk, embroidery, rug- and carpet-making and other folk arts.)
Buraq, Anisa, 'First Conference for the Preservation and Protection of the Palestinian Traditional Cultural Heritage, Tunis, 19–21 December 1982', *Shu'un Arabiyya* (Beirut), 27 May 1983, pp. 197–199.
Collard, Elizabeth, and Wilson, Rodney, 'The Economic Potential of an Independent Palestine', *Samed al-Iqtisadi* (Beirut), 2:12, Jan. 1980, pp. 61–74. (Industrial statistical tables.)
'Creating New Production Branches: Samed News', *Samed al-Iqtisadi* (Beirut), 3:19, Aug. 1980, pp. 196–202. (Gives details of 12 workshops, plus 150 further women in the Folk, Arts and Crafts Division, Lebanon.)
al-Daqs, Muhammad, 'The Palestinian Labour Movement: the Struggle Under the British Mandate (1917–1948)', *Samed al-Iqtisadi* (Beirut), 2:12, Jan. 1980, pp. 75–82. (Includes artisanship.)
Daud, Jalal, 'Industry in the Gaza Strip', *Samed al-Iqtisadi* (Beirut), 3:19, Aug. 1980, pp. 29–59. (Includes hand arts.)
A Dictionary of Folklore (with English/Arabic glossary) (comp. by 'Abd al-Hamid Yunis), Beirut: Librairie du Liban, 1983.
A Dictionary of Semitic Civilizations (comp. by Henry S. Abbudi), Tripoli (Lebanon): Gruss Press, 1988. (Includes Arabic and non-Arabic bibliographies and index.)
'Efforts Towards the Revival of Folk Arts and Crafts in the Occupied

Territories', *Samed al-Iqtisadi* (Amman), 8:59, Jan. 1986, pp. 92–100.

Encyclopaedia of the Mythology and Legends of Ancient Races, with a Dictionary of Important Religious Objects of Worship (comp. by Hassan Ni'meh), Beirut: Dar al-Fikr al-Lubnani, 1994.

'Exhibitions: Samed News', *Samed al-Iqtisadi* (Beirut), 2:14, Mar. 1980, pp. 186–189.

Family Relief Society, al-Bireh, West Bank, *Turmusayya: Studies in Palestinian Society and Tradition*, Beirut: PLO Research Centre, 1973.

Folk Arts (Amman), Jordan Dept of Arts and Culture, 1:1–6, 1974–75 (quarterly).

'Folk Costumes of Arab Women in Palestine', *Folklore* (Baghdad), 2:7, Mar. 1972.

Folklore (Baghdad): Dar al-Jahidh, 12:9–10, Sept./Oct. 1981 (monthly). (Includes folk medicine.)

Freiha, Anis, *Legends and Myths from Semitic Literature* (illuss by Dia Azzawi), 2nd printing, Beirut: Dar al-Nahar, 1979.

Gatt, G., 'Industry in Gaza', *Samed al-Iqtisadi* (Beirut), 4:26, Feb. 1981, pp. 46–54.

'Gold Medallion for Samed at the Leipzig International Fair: Institution News', *Samed al-Iqtisadi* (Amman), 6:49, May/June 1984, pp. 205–208. (Includes statistical tables on embroidery workshops, production and marketing.)

Graf, Pfarrer, 'Die Perlmutter Industrie in Bethlehem' [the Mother-of-Pearl Industry in Bethlehem], *Zeitschrift des Deutschen-Palästina-Vereins*, 38, 1914, pp. 327–338; trans. from German for *Samed al-Iqtisadi* (Beirut), 4:28, May 1981, pp. 118–127.

'Guide to Social Welfare Societies in the Jerusalem District', *Samed al-Iqtisadi* (Beirut), 2:9, Oct. 1979, pp. 20–41.

'Guide to Social Welfare Societies in the Nablus and Jenin Districts', *Samed al-Iqtisadi* (Beirut), 2:10, Nov. 1979, pp. 61–78.

Hadi, Nabil, 'The Lebanese Trade Union Movement from the Ottoman Period to Independence', *Samed al-Iqtisadi* (Beirut), 2:11, Dec. 1979, pp. 74–87. (Deals with the silkworm and silk industry.)

Hammad, Ahmad, 'Samed Projects: New Aspirations and Outlook; Samed News', *Samed al-Iqtisadi* (Beirut), 5:42, pp. 209–221; 5:43, pp. 209–216; 5:44, pp. 185–196; 5:45, pp. 196–198. (Includes Palestinian folk arts exhibits.)

Handhal, Yacoub, *Palestine and Folk Tradition Revival*, New York:

Hanna Salah, 1919. (Includes details of the mother-of-pearl industry in Jerusalem.)

al-Hout, Mahmud Salim, *Arabian Mythology: Research into Beliefs and Arab Lore Before Islam*, 2nd printing, Beirut: Dar al-Nahar, 1979.

Hurani, Hani, 'Aspects of the Jordanian Labour Movement and its Internal Structure in the 1950s', *Samed al-Iqtisadi* (Beirut), 2:11, Dec. 1979, pp. 50–61. (Includes material on the Crafts Trade Unions.)

Istephan, Istephan, 'Animals in Palestinian Folklore', *Tradition and Society* (al-Bireh), 1:4, Jan. 1975, pp. 101–108.

Jordan Ministry of Information, *The Industrial Sector*, Amman, 1965. (Includes material on the tourist industry.)

'July 1 is Palestinian Folklore Day', *al-Jadid* (Beirut), 8 Aug. 1981, p. 12; also in *Samed al-Iqtisadi* (Beirut), 4:32, Sept. 1981, p. 191.

al-Jundi, Ibrahim, *Industry in Palestine During the British Mandate (1917–1946)*, Amman: Dar al-Karmel and SAMED, 1986.

Juzi, Saliba, *The Palestinian Peasant: from Birth to Grave*, Beirut: Palestinian Red Crescent Society, 1975.

Kan'an, Riad, 'Progress in Industry and the Structure of Labour in Israel in the Decade 1971–1980', *Samed al-Iqtisadi* (Beirut), 4:33, Oct. 1981, pp. 104–111. (Includes statistics on textiles, clothes and leatherworks.)

Kan'an, Tewfiq (trans. by Ziad Tartir), 'The Arab House: Architecture and Folklore; the Water Well', *Tradition and Society* (al-Bireh), 4:13, Apr. 1980, pp. 120–122.

Kana'neh, Sharif, et al., *Palestinian Folk Costume*, al-Bireh: Family Relief Society, 1982.

El Khalidi, Leila, 'Origins of Cross-stitch Work in Palestinian Embroidery', *Samed al-Iqtisadi* (Amman), 9:67/68, May/June 1987, pp. 234–237.

—— 'Prototypes of Motifs in Palestinian Costume', *Samed al-Iqtisadi* (Amman), 8:61, May 1986, pp. 205–208. (Also published in Japanese.)

Khudr, Na'im, 'Palestinian Resources; Human, Cultural and Economic', *Samed al-Iqtisadi* (Beirut), 4:30, July 1981, pp. 5–26. (Includes material on traditional arts industries.)

Lamer, Suzanne, 'Palestinian Folk Costume', *Frankfürter Allgemeine*, weekend issue, 6 Feb. 1987; trans. from German by 'Isa Bishara for *Samed al-Iqtisadi* (Amman), 9:67/68, May/Aug. 1987, pp. 238–242.

League of Arab States: Arab Industrial Development Organization (AIDO), 'Country Study for Occupied West Bank and Gaza Strip:

Presented to the Sixth Conference of the Organization', *Samed al-Iqtisadi* (Amman), 5:42, April 1983, pp. 97–146. (Includes material on the tourist industries.)

League of Arab States: Arab League Educational, Scientific and Cultural Organization (ALESCO), *Gazeteer of Palestinian Towns*, Cairo, 1973.

Lestrange, Guy (trans. by Mahmud Amayrah), *Palestine in the Islamic Era*, Amman: Dept of Culture and Arts, 1970.

Marzuq, Muhammad 'Abd al-'Aziz, *Islamic Decorative Arts in North Africa and Andalusia*, Beirut: Dar al-Thaqafa and Iraqi Scientific Council, n.d.

Muslih, Rose, 'Industry in the West Bank, 1967–79', *Samed al-Iqtisadi* (Beirut), 2:13, pp. 23–62; 2:14, March 1980. (Includes relevant statistics.)

Muzayyan, 'Abd al-Rahman, *Palestinian Folklore Encyclopaedia*, 1, Beirut: Occupied Palestine Publications and SAMED, 1981.

Nahhal, Muhammad Salameh, *Palestine Geography: a Politico-Economic Study*, Beirut: Dar al-'Ilm-lil-Malayin, 1966. (Includes details of the Jericho, Bethlehem, Hebron, Nablus and Jaffa artisan industries.)

National Orthodox Welfare Committee, Bethlehem, untitled booklet, Nov. 1986.

al-Nunu, Samia, 'The Palestinian Folk Heritage: its Importance and the Palestinian Revolution's Influence on it', interviews in *Samed al-Iqtisadi* (Beirut), 3:21, Oct. 1980, pp. 165–173. (Includes sketches of costumes and notes the present author's work.)

'Palestinian Costume with Dancing Feet, Rhythm and Organ Music', *Occupied Palestine* (Beirut), 117, 15 May 1978, pp. 46–48.

'Permanent Exhibit for SAMED's Folk Arts and Crafts; SAMED News', *Samed al-Iqtisadi* (Beirut), 2:11, Dec. 1979, pp. 165–166.

PLO Research Centre, *Palestine Geographical Lexicon* (gazeteer) (Palestine Books Series, 16) (comp. by Qustantine Khammar), Beirut, 1965.

—— *Place Names, Topographical Description, Population and Geographical Landmarks in Palestine up to 1948* (Palestine Books Series, 43) (comp. by Qustantine Khammar), Beirut, 1973.

Qa'war, Widad Kamel, et al., *Palestinian Embroidery: Traditional Cross-stitch Work*, Munich: National Ethnic Museum and SAMED, 1992.

Rabah, Rawhi, 'Samed: the Other Face of the Palestinian Revolution', interview with Ahmad Qurei' (Abu 'Ala'), in *al-Liwa'* newspaper (Beirut), 21 July 1980; also published in *Samed al-Iqtisadi* (Beirut), 3:19, Aug. 1980, pp. 170–171.

Sa'di, Ghazi, 'A Study of Arab Labour in Occupied Palestine', *Samed al-Iqtisadi* (Amman), 5:43, May/June, 1983, pp. 95-103. (Includes artisanship statistics.)

Salam, Rifa't, 'Searching for the Arab Folk Heritage', *al-Manar*, 1:2, Feb. 1985, pp. 112-140.

Salim, Muhammad 'Abd al-Ra'uf, 'Jewish Industry in Palestine Under the Mandate', *Samed al-Iqtisadi* (Beirut), 2:10, Oct. 1979, pp. 78-95.

Samara, 'Adel, 'The relation Between Economics and Tradition', *Tradition and Society* (al-Bireh), 1:1, Apr. 1974, pp. 80-84.

Samara, Samih, 'The Economic Basis for the Peasant *Intifada* Uprising in Palestine in 1929', *Samed al-Iqtisadi* (Beirut), 2:11, Dec. 1979, pp. 15-31. (Includes details of the working conditions of Arab artisans.)

Samed al-Iqtisadi (Amman), special issue on the Palestinian folk heritage, 9:67/68, May/Aug. 1987.

Shahrur, Muhammad, 'Interview with Leila El Khalidi on the Collection and Documentation of Palestinian Folklore', *Samed al-Iqtisadi* (Beirut), 2:9, Oct. 1979, pp. 179-181.

al-Sharif, Maher, 'A Contribution to the Study of the Mechanics of the Beginnings of the Palestinian Arab Labour Movement', *Samed al-Iqtisadi* (Beirut), 3:18, July 1980, pp. 50-77. (Contains statistics on artisanship.)

—— and Badran, Nabil, 'The Rise and Development of the Palestinian Labouring Classes' (parts 1-5), *Samed al-Iqtisadi* (Beirut), 4:26, Mar. 1981; 4:27, Apr. 1981, pp. 34-48; 4:28, May 1981, pp. 5-26; 4:29, June 1981, pp. 5-39; 4:30, July 1981, pp. 27-35. (Includes nineteenth-century references and data.)

Shihadeh, Amal, 'Palestinian Folklore Studies: a Bibliography', *Samed al-Iqtisadi* (Amman), 9:67/68, May/Aug. 1987, pp. 199-214.

Sufan, Laila, 'From the Library of Amman Training College: a Listing of Titles on Arab Folklore in Arabic Periodicals', *Teacher/Student* (Amman), UNRWA/UNESCO Publication, May 1982.

Technical Engineering, Arab Management Institute (TEAM), 'Economic Projects and the Labour Market in Palestinian Institutions in Lebanon; SAMED; Marketing', *Samed al-Iqtisadi* (Amman) (2 parts), 6:47, Jan./Feb. 1984, pp. 59-89; 6:49, May/June 1984, pp. 191-204.

Tradition and Society (al-Bireh), quarterly publication of the Family Relief Society, al-Bireh, West Bank, 1974-.

United Nations Development Program (UNDP), 'Document on the Assessment of International Organization for the Needs of the

Palestinian People: a Report' (2 parts), *Samed al-Iqtisadi* (Beirut), 2:12, Jan. 1980, pp. 138–167; 2:13, Feb. 1980, pp. 124–155. (Includes details of small industries, e.g. embroidery, and SAMED's role as enhanced by its present workshops.)

Works Committee for the Rehabilitation of Girls in the Hand Arts, Embroidery and Sewing, West Bank, *Gaza Strip Year Reports*, 1980–1982.

Yusif, Ahmad, and Khaffaji, Yusif, *Ancient Egyptian Decorative Arts*, Cairo: Madbuli Book Publishers, n.d.

Zaru, Samia, 'Our Folk Heritage', *Educational Planning* (Amman), Sept. 1981, pp. 60–64.

—— 'Some Palestinian Folk Arts and Craft Works', *Teacher/Student* (Amman), UNRWA/UNESCO Publication, May 1982, pp. 22–30.

Zimmu, Rida, and Abu Wardeh, Farid, 'Palestinian Folk Art Selections', *Teacher/Student* (Amman), UNRWA/UNESCO Publication, May 1982, pp. 54–59.

Non-Book Material

1. A collection of cumulative files from newspaper and periodical clippings of Arab costume, including dress, jewellery and headdress, Beirut 1979–83, Athens 1983–84, Amman 1985–87 (subsequently lost in Beirut and Amman offices).
2. A collection of nineteenth- and twentieth-century costumes with full accessories, bought in Amman 1986–87 (now relocated to Tunis).
3. Project for a library of colour slides and other audiovisual material, including files of embroidered motifs (lost in Beirut, 1982, and Amman 1987).

Index

abas (men's cloaks) 50
Abu Said II Khan 26
Acanthus 92
Afghanistan 68, 145*n*
Africa 34, 68
Ak-Buran 144*n*
Alexander the Great 23
Alexandria 23
Allenby, General Edmund 49
Amenhotep II 21
America 33-4
 influence 49, 50
Amman 55
Ammonites 22
Amorites 20
Amulet (design) 92-3
amulets 72
Apples 94
appliqué work 44, 45
Arab Americans 50
Arabesque Muslim motifs 33
Arabian peninsula 68
Arabs 22, 23, 26, 32
Aramaeans 21, 22
Arch 94-5
Argentina 68

Armenia 68
Assisi counterchange cross-stitch 26, 33, 67, 74
Assyrians 20, 22
Austria 66, 68

Babylonians 20, 22
Bachelor's Cushion 95
Baker's Wife 74, 131-2
Balkans 29, 34, 50, 51, 66, 68, 145*n*
Baltic states 68
Bayeux Tapestry 25
bedouin 40, 43, 59, 145*n*
Beisan 40
Beit Jala 51
Belgium 25, 66
belts 41
Berlin 31
 wool work 28, 146*n*
Bethlehem 40, 43, 51, 59
 work 43, 44, 53
Bolivian Indians 68
Botticelli, Giovanni 26
Boudicca 24
Brazil 68
Britain 24, 27, 29, 68

influence 49, 50
 motifs 33
British mandate 49
British Museum, London 31
Bulgaria 68, 145*n*
Burgundy 66
button-holes 44
Byzantine Star 95

Cactus Fruit 96
Cairo, Khan al-Khalili souq 145*n*
Calabria 25
calligraphy 22
Canaan 21
Canaanites 20, 22
Candlestick 96-7
Canton 28
canvas-over-cloth method 44
care of clothing 45
Carnations 97-9
'carpet' design 74
Caucasian states 68
Cauliflower 99
Central America 11, 22, 40, 68
Central Asia 51
ceremonial occasions 48, 52-3, 59
Chain 99
chain-stitch 74
Chaldeans 22
Charlemagne, Emperor 25
Chick-peas and Raisins 99-100
Chile 68
China 19, 20, 22, 23, 24, 25, 27, 28, 29, 31, 33, 40, 65, 67, 68, 74
Chinese Cloud 100
Chinese–Mongol designs 26, 33
Christianity 24, 26, 33, 34, 49-50
 and mission schools 49, 51-2
chronology 19-29
church sculpture 32
cloth, as background for embroidery 41-2
 store-bought 42
Cock 101
Cock's Comb 101
coin ornaments 40
collections, national, plans for 60, 83-4, 87

Cologne 27
colour schemes 43, 55, 145*n*
Connecticut 28
Constantinople (Istanbul) 23, 25
Coptic Christian motifs 33
Corn 102
costume
 design 42-3
 pageantry in 39-45
counted thread work 42, 43, 44, 59
counterchange 26, 33, 45, 67, 74
Cow's Eye 102
Crab 103
crafts 50
crewel work 27, 50
Crimea 144*n*
cross-stitch 26, 27, 32, 44, 50, 52, 58
 African 34
 folk 28
 Inca 33-4
 Islamic 31
 long-armed 44
 motifs in (to 1948) 65-80
 North American Indian 33-4
 origins of motifs 65-75
 as peasant craft 66
 Scandinavian 34
 Slavic 34
Crown 103
Crusaders 26, 67
cushions 44, 50, 52
cut-outs 44
Cypress Tree 103-5

daisychain stitch 44
Damascus 13
Damask Rose 105
Danzig 26
Dar Batha Museum, Fez 31
developments in skills 57-61
documentation 67
domestic service 54
Dragon 105
Dragonfly or Snapdragon 106
drawn thread 32
dress-front squares 74
dresses 40
 young girls' 48

Dürer, Albrecht 26
dyes 20, 21, 42, 50

Earlier Han dynasty 23
Ecuadorian Indians 68
edgings 45, 74-5
Edomites 22
Egypt 19, 20, 22, 23, 65, 68
 motifs 33
embroidery skills
 commercial use of 54-5
 developments in 57-61
 importance for marriage 52-3
 revival 55
 taught to young girls 52, 58
Emperor Dragon 28
Ethiopia 23
Eyes 106

Farmer's Wife 107
Feathers 107
Fertile Crescent 21, 26, 28
Fez, Morocco 31
fieldwork 85-7
fillings 74
finishing techniques 44, 45, 57
Finland 68
Flower Pot or Vase 107-8
Flowers 109
folk art, embroidery as 47-56
folklore 41, 55
footwear 41
Fountain of Life 109
France 26, 27, 66, 68
 influence 49, 50
Francis I, King of France 27
Francis, St 26, 32
Franciscans 26
Frederick II, King of Sicily 26
French motifs 33
Frogs in a Pond 109
Fruit Tree 109-10

Gates of Heaven 32, 67, 110-11
gauze cloth 42, 43
Gaza Strip 39
geometric styles 32
Germany 27, 28, 66, 68

motifs 32-4, 49, 50
ghabani 59
gold pieces 72
gold thread 27, 43, 49, 74
Grapes 111
Great Exhibition, London (1851) 28
Greece, Greeks 22, 23, 25, 65, 68, 144*n*, 145*n*
Greek Cross 32
Guardian Angels 32, 67

half-cross-stitch 68
handlooms 27, 29
Hastings, battle of 25
Hawthorn 112
headbands 41
headdresses 40, 44
Heart 112-13
Hebrews 21, 22
Hellenic motifs 33
hemstitch 74
Hittites 21, 22
Holbein stitch 32
Holy Candelabrum 32, 113-14
Holy Cross of Jerusalem/Bethlehem 67
 see also Jerusalem Cross
Holy Keys of Bethlehem 32
Holy Keys of Jerusalem/Hebron 67, 114
Holy Mount 114
Holy Salver 115
Holy "S" (serpent) 32, 67, 115
Holy Star of Jerusalem/Bethlehem 32, 67, 115
Hoopoe 115-16
house-dresses 42, 48
household furnishings 52, 66
Huguenots 27
Hungarian motifs 33
Hungary 25, 29, 66

Iceland 68
Inca motifs 33-4
India 28, 29, 65, 68
Inuit 24
Iran *see* Persia
Islam 23, 34

see also Muslims
Istanbul 49
Italy 25, 32, 50, 66, 68
 influence 49
 motifs 33

jackets 40
Jaffa 43
Japan 27, 28, 29
Japanese 23
Jenin 59
Jericho 40
Jerusalem 31, 35, 40, 59
Jerusalem Cross (Crusader Cross) 116-17
Jesuits 27
jewellery 41, 43
Jews 21, 22, 26, 51
Jordan 21, 68
 refugee camps 39, 56
Jordan river basin 59
Justinian, Emperor 23

Kelim designs 24, 33
Key of Hebron 117
key motifs 67
Knights Templar 26
knitting 50
Kohl Bottle 117-18

Ladder 118
Lamps or Lamplights 118-19
Lapland 68
Later Han dynasty 24
Lebanon 13-14, 21, 40, 56, 68
Lily 119
linen cloth 19
Lions 120
llama hair 27
London 28, 29, 31
London Broders' Company 27
loom, vertical 22
Louis XI, King 26
Louis XIV, King 27
Lovebird 120
Lower and Middle Ghor regions 40
Lutherans 27-8
Lyon 26, 27

Macedonians 23
 motifs 33
machine sewing 44-5, 54, 57
Maeseyck 25, 66
magazines and books on embroidery 59-60
Maghrebi motifs 33
Magyars 25, 29
 motifs 33, 34
Maintenon, Françoise, Marquise de 27
majdal (striped cloth) 42, 43, 59
Mawangdui 23
Mayas 22
Medici, Catherine de' 27
Mernaptah 21
Mesopotamia 20
Mexico 20, 40, 68
Mihrab (prayer niche) 120
Millwheel 121
mission schools 49, 51-2
Moabites 22
Montpellier 26
Moon 121
 of Bethlehem 123-4
 and Feathers 122-3
 foreign (St Anthony's Cross) 123
 of Ramallah 124
motifs 23-9, 32, 33, 55, 65
 animals 79
 beliefs or religious symbols 77-8
 birds and fowl 79
 border 74-5
 branches 73-4
 courtyards and gardens 78
 edgings 45, 74-5
 exchange of 50-1
 field produce 78
 'foreign' 73
 home life or implements 79-80
 as personal identification 72
 possessions or decorative objects 80
 rural scenes 79
 as tradition 73
 units 73
mourning clothes 43, 145*n*
Mulberry 124

Museum of Mankind, London 31
Muslim Egyptian motifs 33
Muslims 26, 50, 50-1
 see also Islam

Nabataeans 22
Nablus 43, 51, 59
al-Nasir al-Din Muhammad ibn
 Qalawun 26
naturalistic forms 32
Nazareth 51
needle-painting 146n
needlepoint 146n
needles 57
needlework (as term) 145-6n
Negev 40, 145n
Neo-Gothic motifs 33
Netherlands 66, 68
nomadic peoples 20, 22
North Africa 26, 34, 68
 motifs 33
North America 40, 68
 Indians 24, 28, 33-4, 68
Nuremberg 27

Odo, Bishop 25
Old Man's Teeth 124-5
Old Testament scenes 27
Ottoman empire 26, 28, 49
 influence 40
 motifs 33
 see also Turkey
outdoor and indoor clothing 42, 48
over-garments 40, 41, 42
overlay 74

painting 22
Palermo 25
Palestine 20, 21
 geographical divisions (pre-1948) 35-6
Palm (of hand) 125
Palm Trees 126
Palmyrans 22
Paris 26, 27
patchwork 28, 44
pattern books and magazines 65, 73
Peacock 126-7

Pegtops 127-8
Pergamon Museum, Berlin 31
Persia (Iran) 23, 26, 34, 68
 designs 32
 influence 51
Persian/Farsi designs 33
Persians 22, 23, 26, 65
Peruvian Indians 68
Pharaonic–Coptic designs 26
Phoenicians 21, 22, 32
Pigeon(s) 128
Poland 68
Pool or Harp 129
Portugal 26
Ptolemaic dynasty 23
purple dye 21
Pyramid of the Sun 23

Ramallah 40, 43, 51
 cloth 41, 59
Ramallah-al-Bireh 40
Ramses II 21
Ramses III 21
recycling of materials 44, 45, 52, 60
Regensburg 26
religious ornament 50
Rhineland 66
Road to Egypt 73, 129
Roberts, David 39
Rockefeller Museum, Jerusalem 31
Roger II, King of Sicily 25
Romania 66
 motifs 33
Rome, Romans 23, 65
 motifs 33
Rose 130-1
Roundabout or Baker's Wife 74, 131-2
Royal School of Needlework, London 29
rugs 50, 65, 68
running stitch 45
Russia 28, 50
 motifs 33, 66

St Cyr, Convent of 27
SAMED 9, 11
samplers 66, 67

satin 27
satin-stitch 44, 45
Saw 132-3
Saxony 27
saya (Syrian striped material) 40, 42, 59
Scandinavia 68
 motifs 33, 34
scarves and shawls 40, 41
Scorpions 133
'scythes' 45
Seleucids 23
Semitic groups 20-1, 23-4, 26
Shanghai 28
Shepherd 134
shoulder strips 45, 74
Siberia 68
'Sicilian' 32
Sicily 25, 26
silk 19, 20, 22, 23, 26, 27, 28, 49
 export of 28
Silk Route 24, 25, 34, 144n, 145-6n
silk trade 49
silkworms 27
 raising 143n
 smuggled 23
silver thread 27, 43, 74
Sinai desert 40, 145n
'Skalli' Birds 32, 134-5
Slavic areas 34
Slavic motifs 29, 33, 50
Slovenian motifs 33
Snails 135-6
Snake and Serpent 136
Snowflakes 137
Soap 138
Sotheby, Susan 39
South America 27, 68
South American Indians 23, 66
South Korea 29
South-east Asia 68
souvenir trade 50
Soviet Union (former) 68, 145n
Spain 26, 34, 68
Spanish motifs 33
Stick 138
stitchery 44
Sumerians 21

Sunflower or Garden Rose 139
Swabia 66
Swan 139
Switzerland 28, 68
symbols, migration of 31-4
Syria 21, 25, 32, 40, 59, 68
 refugee camps 39, 56
Syrian Inhabited Scroll 32, 67, 139-41
Syrian/Phoenician motifs 33

tariffs, protective 28
techniques 44-5
tent-stitch 27, 66
Teotihuacanos 23
terminology 89, 145-6n
Thebes 25
Theodorus Prodromus 145n
thread 42
 colour 43
 cotton 42, 43, 50, 53, 57
 gold 27, 43, 49, 74
 silk 42, 43, 57, 66
 silver 27, 43, 74
 wool 50, 66
Tiberias 51
Tomatoes 141
tourist trade 50, 59
Tours 26
trans-Danubia 68
 motifs 32-4
Transylvania 28, 66
 motifs 33
Transylvanian Saxons 26
Tree of Life 32, 67, 141
Trefoil 32, 67
trousers 40, 42
trousseau 47-8, 52-3
Turkestan 68
Turkey 34, 68, 145n
 motifs 33
Twelve Symbol robe 28, 33
twisted overwork couching stitch 44
Tyre 21

Ukraine 68
United Nations Relief and Works
 Agency 55
United States of America 33

Upper Galilee 40
Uruguay 68
USSR 29
Uzbekistan 68

vase paintings 22
veiling 40-1
velvet 53
Venice 26, 27
 motifs 33
vicuna hair 27
village dress 41
Vinciolo, Frederick di 27
 Les Singuliers et Nouveaux Portraits et Ouvrages de Lingeries 27
volunteer outlets 55

Wall of Jerusalem (citadel) 142
washing-day procedures 45
water-carrying 48
Watermelons 142
weaving devices 27
weddings 48, 52-3
West Bank 39
West European motifs 33
William the Conqueror 25
women
 education of 51-2
 significance of personal clothing and jewellery 71-2
workshops, present-day 55, 60, 83-4, 85-6
 sponsorship 86-7

Yugoslavia (former) 66, 68, 145*n*
 motifs 33

Zhou dynasty 22
Zwickau 27